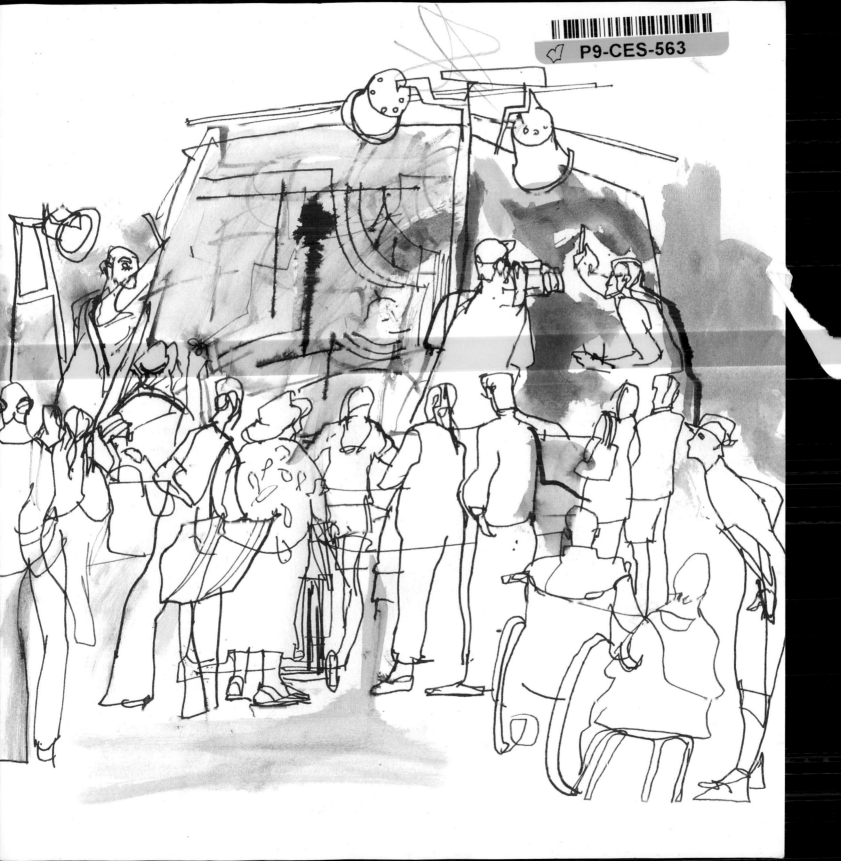

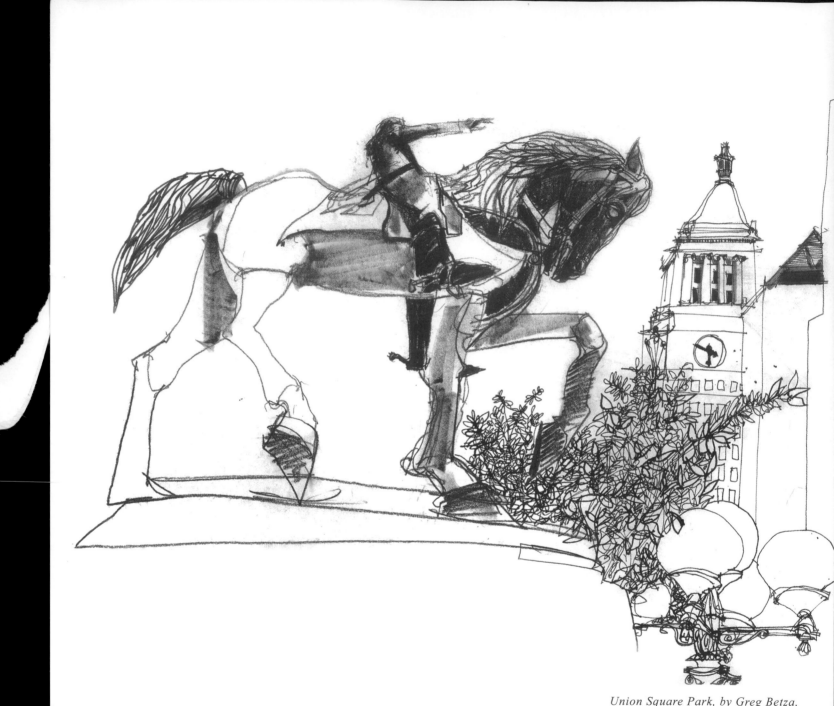

Union Square Park, by Greg Betza,
Graphite and ink on paper

Contents

Introduction .. 6

Chapter One: Getting Started... 8

Chapter Two: Line and Mark.. 14

Chapter Three: Playing with Color... 32

Chapter Four: People Watching and Capturing Motion.......... 50

Chapter Five: Close to Home.. 66

Chapter Six: City and Country ... 78

Chapter Seven: Ideas, Holidays, and Special Projects 94

Chapter Eight: Gallery... 110

 About the Author ..126

 Acknowledgments128

INTRODUCTION

> *"The important thing is to do,*
> *and nothing else; be what it may."*
> —Pablo Picasso

Artist on location, by Kati Nawrocki,
ink with brush and photo collage

TO MAKE ART is a sometimes mysterious, sometimes rewarding, and sometimes frustrating process. If you are already an artist, you know exactly what that means. If you have never attempted to create a piece of art and are thinking of embarking on this journey with us, you will find out what that means. To be an artist means to invite an occupation into your life that requires commitment and hard work, but the rewards and satisfaction you'll get make the work seem like play. But you have to do it every day.

This leaves us with the question: doing *what* every day? Creating *what*?

Often the hardest part for any artist, from beginner to professional, is getting over the hurdle of the so-called white-page syndrome (as in, what do I put on that white page?). The *One Drawing a Day* philosophy is about the possibilities inherent in that white page. It's a philosophy of creating art without restraints or obligations. By committing to produce just one drawing a day, of anything, for no other purpose than to do it, the Studio 1482 illustrators incorporate art as part of our lifestyle. It's not necessary to block out a special day or two weekly to work on your art; in fact, that sort of emphasis can be detrimental. Who hasn't experienced that moment

when you are at your drawing table (or dining room table) with pencils sharpened, crayons ready, paint squeezed out on the palette and you are … totally blocked. Frozen. Your setup and materials are so good that you've psyched yourself out! And if you have beautiful, expensive paper that your well-meaning friend or loved one has given you, then the pressure to perform can be even worse.

What if you simply picked up a cheap disposable pen and a piece of even cheaper paper and made a drawing? Without taking too much time. Without judging the result. Without worrying about drawing something important; in fact, simply drawing whatever is right in front of you. Boom. You've just made your first drawing.

What if you did that once a day, every day, varying your materials, your location, and your thinking? You would then be on your way to discovering your artistic potential. And if you made the commitment to do this every day for six weeks, then you would be on your way to creating the habit of artistic study that makes a good artist great.

That's the premise of this book.

Studio 1482 is comprised of eight working illustrators: Greg Betza, Michele Bedigian, Despina Georgiadis, Margaret Hurst, Veronica Lawlor, Kati Nawrocki, Eddie Peña, and Dominick Santise. We have used the *One Drawing a Day* method to keep our work fresh and alive. When we met as students, years ago, we set our sights on becoming professional artists and illustrators. Now that we have done that in our various ways, we are faced with a new question: How do we keep alive the spirit of study and experimentation that brought us to this point, when we are often commissioned to perform our illustration a certain way for our clients? Our blog, *One Drawing a Day*, allows us to do that. We can play, experiment, and foster the growth that is

essential to an artist's survival without compromising the work we deliver to our clients. After all, we're happy to have them! And as our experiments grow they improve the illustration work we deliver as well.

Using the Studio 1482 posts on the *One Drawing a Day* blog as a springboard, this book will lead you through six weeks of drawing. That's forty-two daily exercises designed to motivate you to make art. Some of them will encourage you to work with various media such as pen and ink, pastel, watercolor, or collage. Some will encourage you to visit places in your hometown or further afield to draw. Some will ask you to do a bit of research. All of them will encourage you to expand your horizons. You can do the exercises in the order presented or jump around as your mood dictates. The most important thing is to complete them all in a way that works for you. There are tips to guide you along and variations on the exercises in case you want to take them further. By the end of the six weeks you should be on the way to establishing the habits that will keep you motivated to continue drawing.

It's work, for sure, but it's work that we love. We really believe in the honest practice of our illustration craft without boundaries, to find out where this artistic journey will lead us. Through the forum of our blog, we can critique each other, encourage one another, or simply enjoy each other's work— and hopefully find an audience of viewers who enjoy it as well. It's been gratifying and rewarding, and we at Studio 1482 hope that the *One Drawing a Day* philosophy can work for you too.

So let's get started …

Chapter One:
GETTING STARTED

Seeds, by Kati Nawrocki, marker and crayon

What You'll Need

As with any new journey that we take in our lives, it is important to prepare. Now that we've decided to get started on our *One Drawing a Day* adventure, the next step is to assemble the tools we'll need to complete the exercises in this book. You can purchase them as you go along or take an afternoon at an art supply store and go on one big buying spree! Be sure to compare the prices in your local store with the prices you can find in online resources to get the best deal.

For the exercises in this book you will need the following:
PENCILS Choose a range of at least six graphite pencils, from soft (6B) to hard (3H). Along with the pencils, it would be good to pick up a small sharpener and a kneaded eraser. You can also buy a small, battery-operated electric sharpener to use both at home and on location.

CHARCOAL Pick up a few charcoal pencils and a small box of compressed charcoal to use for some of the exercises in chapter two. You may also find a box of Conté crayons to be an interesting variation on the charcoal line. You can purchase small, pointed smudge sticks to use in addition to your finger for smearing the charcoal.

A small spray can of workable fixative will be useful to keep those charcoal and pastel drawings on the page; be sure to use the spray fix in a well-ventilated area, or outdoors, and don't breathe in the fumes. Hairspray works well in a pinch.

FOUNTAIN PEN A fountain pen that uses cartridges is more convenient, especially for the location exercises we will be doing, although you can buy one with a refillable reservoir if you prefer. The prices of pens vary widely: A pen with a gold tip will be more flexible but also more expensive. If you are new to this, you might want to begin with a less expensive model or even buy several disposable fountain pens to play with. You can always go for a better grade of fountain pen once you are more familiar with it and have a better idea of what you prefer in the pen's quality.

INK You'll need at least one bottle of loose black ink, either waterproof or water soluble. The choice is yours; waterproof ink is thicker and may dry more quickly. For refillable fountain pens, always use water-soluble ink. This protects the pen's interior and point from hardened ink residue. You may also want to invest in a professional pen-cleaning solution; a small jar is fairly inexpensive and will help you keep your pens in good shape.

NIB HOLDER AND NIBS You'll need a crow quill or calligraphy dip pen and a range of nibs. Buy at least two holders and an assortment of nib sizes and styles to experiment with.

BAMBOO PENS A bamboo pen is carved from a piece of bamboo and gives a nice, graphic line. Buy at least three different thicknesses to play with.

WATERCOLOR PAINTS Purchase a small watercolor pan set and several individual tubes of watercolor paint. Choose a pan set that has a range of at least 12 colors; it doesn't need to be expensive. When choosing your watercolor tubes, try a set or pick your own colors out. Choose at least one shade of each of the primary and secondary colors for mixing, and a few that appeal to you visually, to start (primary colors: red, yellow, blue; secondary colors: violet, orange, green). Purchase a tube of black and one of white, as well.

WATERCOLOR BRUSHES Buy a minimum of two: one small and one large. Buy a size in-between if you have the extra funds. Natural sable is my personal favorite, but the price can be prohibitive. Don't hesitate to choose student-grade brushes to begin with: You can always upgrade them at a later time. It is also a good idea to purchase a small spray bottle that you can fill with water and spray mist your watercolor paints and/or paper during the process of painting.

CRAYONS AND MAGIC MARKERS A small box of children's crayons and a small selection of thick children's Magic Markers will be used for one of the color exercises in the book. You can pick these up very inexpensively at most stationery stores or supermarkets.

WATERCOLOR CRAYONS It's a good idea to have a set of water-soluble crayons to work with. Buy a small tin of at least twelve, or select your own colors to buy individually and make a set in a small plastic box.

PASTELS It would be good to purchase a small set of soft pastels in stick form: A box of at least twenty-four colors will give you a good range. In addition you may choose to purchase some pastels in pencil form; these can be really useful on location.

COLORED PENCILS A small set of colored pencils is also a must for these exercises. Try a few brands to find the softness you like; I prefer a softer line, but your taste may run to a harder one. You can buy these pencils in sets, but it is more personal if you choose the individual colors yourself and create a small kit in a pencil case. At least 15 pencils in different shades of the primary and secondary colors will give you a good range; you may also want to include a white and black pencil and a few grays. As a variation, you might purchase a few water-soluble pencils to throw into the mix.

OIL CRAYONS Oil-based grease crayons are terrific to work with, as they give an entirely different feel to your work than the water-soluble ones. Choose a set of at least twelve or select colors to buy individually and make your own set in a small plastic bag. You might also purchase a small container of turpenoid (a turpentine substitute) and an inexpensive brush to achieve some more painterly effects with these crayons. The coverage is very rich, and so is the color!

PAPER A simple white drawing paper that takes both wet and dry media will work best for most of the exercises in this book. Occasionally, special charcoal or watercolor papers are recommended—you can often buy these papers by the sheet at your local art store or online. See if you like the paper before you invest in a large pad of it! A small (9″ × 12″ [23 × 30 cm]) pad of tracing paper will come in handy as well.

EXTRAS Scissors, tape, and a small glue stick will be useful for the collage exercises in this book, as well as a small craft

Fountain pen, dip pen, bamboo pen, brush

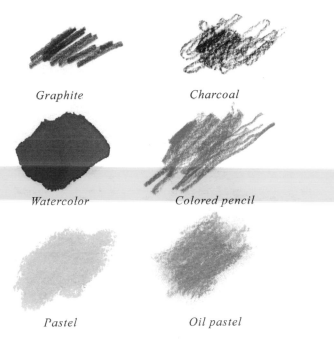

Graphite *Charcoal*

Watercolor *Colored pencil*

Pastel *Oil pastel*

knife for fine cutting. Some of the exercises use the computer as an alternate to traditional cut and paste. If you have computer access, you might want to try a free online trial of a graphics program such as Photoshop to play with during our six-week journey. (If you don't have computer access, traditional cut and paste will work just fine.)

Plastic bags and small jars with screw-top lids will come in handy for location work.

OTHER OPTIONS Not necessary for the exercises in this book, but you might want to try gouache paints, pan pastels, watercolor dyes, and oil sticks. These are for when you've completed the six weeks and are eager to try something else! The best part of working with art is that there are as many options as there are ideas.

Where to Work: Studio and Location

For the exercises in this book, you will be asked to work both in your home studio and on location. Here are some suggestions for setting up your home working space as well as a location-ready artist's kit.

You don't need to have a separate room in the house for your art studio, although if you do, that's a luxury you should take full advantage of. It would be ideal, however, to have a small space where you can set up a workstation on a permanent basis. This keeps you from having to set up the space each time you want to work and take it down each time you're finished. If you can't afford to turn over a part of your living space to art, you can use your dining room or kitchen table. If you do that, though, it's best to have a small box or bag that holds everything you need, including a plastic tablecloth, so your setup and takedown time will be minimal. Too much complication in your art setup will create an open door for procrastination to stroll through!

TABLE You'll need a sturdy table to work on. Choose either a drafting table that tilts or a solid table with a flat surface. You'll be painting and drawing on this surface, so think in terms of something that is easy to clean. Keep it simple, and don't hesitate to look at student-grade furniture. You'll also want to invest in a small self-healing cutting board to cut collage materials on without disturbing the surface of your drawing table. Most art supply stores carry them.

STORAGE Next to the table you will want a taboret or small cabinet to hold your art supplies and also provide a surface to put your tape dispenser and current project supplies on. You'll also need small trays or boxes for crayons and jars or ceramic mugs to hold your pens, pencils, and brushes and a small jar for ink and one for water. Having a roll of paper towels stored in your work area is a good idea as well.

LIGHT Make sure your table is positioned to receive a good amount of light, either near a window or under a strong overhead light. In addition, you'll need a small clamp-on lamp to focus even more light on your subject. Again, it is not necessary to spend a lot: An inexpensive student-grade lamp will do just fine.

SEATING Get a chair that you will be comfortable in to accompany your worktable. You don't want to be squirming around and uncomfortable while creativity is happening!

If your work surface is the dining room or kitchen table, be sure to clear it off completely before setting up your work materials. Nothing distracts from our purpose more than mail, or yesterday's leftovers, lying next to our art page.

Location Setup

Create a location kit. Use small plastic bags to put into a shoulder bag or get a small art-supply box—whichever you will be more comfortable with. Most art stores sell a small art-supply box with a handle, or you can use a fisherman's tackle box or toolbox. My preference is to put my materials in plastic bags and throw them into a shoulder bag, as it feels more spontaneous. Also, I can easily adjust what supplies I need for a specific situation rather than lug all of my supply options in a tackle box each time. But your personal preference should rule here—you want to be as comfortable on location as you can be.

You'll also need a drawing board and a few clips for attaching your paper or sketchbook to the board. A small Masonite board, about 17″ × 11″ (43 × 28 cm), should give you a nice mobile drawing surface to lean on when working, even those cases in which you may be forced to draw standing up.

Also extremely useful on location is a water pen—a small brush with an empty barrel to hold water for painting. It's much more convenient and less likely to spill than a jar of water. Of course, if you prefer to use the jar, get a small plastic one that has a tight screw-on lid.

Fountain pens are generally more portable and convenient on location than a bottle of ink and a dip pen, but if you prefer the dip pen, make sure to put your ink in a jar with a lid that's tight and an extra plastic bag for protection.

The rest of your supplies should be packed either in your supply box or separately in plastic bags; neatly, so you know where to find everything once you are out in the field. A few folded-up paper towels thrown in your bag for good measure will never cease to be of use on location.

Here are other things to consider packing in your location drawing kit: fingerless gloves and ear muffs for cold weather, a small clear rain poncho and portable umbrella for rainstorms, sunscreen, a bottle of water to drink and also to use for your art in a pinch, some small snacks, a little container of hand sanitizer, tape, and a business card that lets people know you are a location artist (in case you need permission to draw somewhere, or meet an admirer of your work).

You might also consider purchasing a small foldable stool to sit on. Many sporting goods stores make these for campers: It's nice to always have the best seat in town! Make sure you buy a light one, as supplies can get heavy when you are carrying them around for hours.

Two other luxury options are a small digital camera for image backup and a small digital tape recorder to record your own thoughts on location, the words of someone you are drawing, or the ambient noise of a place. Sound is as much a part of the location experience as the visual. Lastly, be sure to bring a few tissues and Band-Aids for emergencies. Location work can be a little like camping—you never know what to expect!

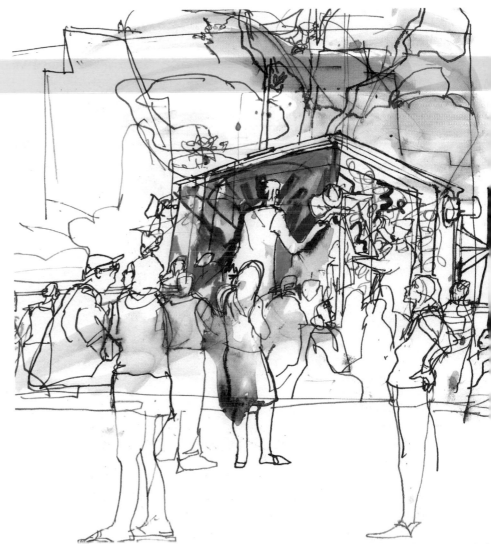

Public painting event,
location drawing by Veronica Lawlor,
ink, watercolor, and crayon

Bethesda Terrace, Central Park, by Eddie Peña,
pen and ink with wash

Chapter Two:
LINE AND MARK

First Step

Sometimes that first step is the hardest. Studio 1482 illustrator Michele often likes to do a still-life drawing to warm up for the day. Something simple and readily available such as a composition of things in your home can be a perfect way to get out of that "what to do" confusion. Michele loves to keep freshly cut flowers in her studio, and books are her passion second only to family and friends, whom she entertains often. So why wouldn't she like to draw them?

EXERCISE 1

Select a few items in your home and create a still life with them. Choose things that mean something to you or your family. Alternatively, you could simply sit down in front of your kitchen table, a shelf, your dresser top, or any place in your home where collectibles or things you use every day are displayed. Pick up a razor-point pen or marker and put it to paper. Draw continuously, picking the pen up from the page only occasionally. Give yourself permission to make mistakes in the drawing: Judging a drawing midstream stops creativity, and we are only at the beginning of our *One Drawing a Day* journey!

VARIATION

Once you have done your still life, you might like to try drawing someone in your home. Pick someone who is relatively still, as in this drawing Michele did of her father reading. Hold your pen farther back and keep your hand off the page. Don't worry about likeness or correct proportions; simply observe the person and experience the drawing.

Pen line drawing of Dad reading in the afternoon

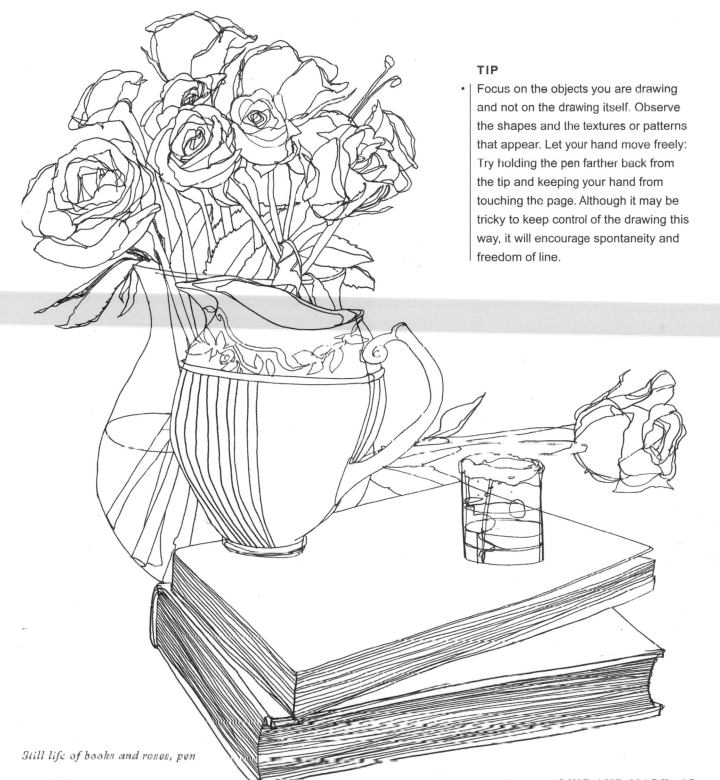

TIP

- Focus on the objects you are drawing and not on the drawing itself. Observe the shapes and the textures or patterns that appear. Let your hand move freely: Try holding the pen farther back from the tip and keeping your hand from touching the page. Although it may be tricky to keep control of the drawing this way, it will encourage spontaneity and freedom of line.

Still life of books and roses, pen

Butterflies, Roses, Caterpillars, and a Lady

"This drawing was inspired by, and drawn in, the English rose garden at Epcot. It was fun just to draw roses and butterflies and caterpillars and then imagine a beautiful lady sitting in the middle of the garden." —Margaret

EXERCISE 2

Today's exercise involves the variation of line thickness and calligraphy that you can achieve with an old-fashioned dip pen and some black or brown ink. Get a nib holder and an assortment of nibs in different sizes. Speedball makes a good range: Try the fine-line ones as well as the broader nibs meant for calligraphy. You might want to get a few holders so you can have the different nibs available to use in one drawing.

Go to a garden or set up a gardenlike still life in your home. Roses are always romantic, and if you are outside, keep your eyes open for a butterfly. Make the drawing directly with the ink on paper; don't pencil anything in first. See what kinds of lines you can produce. Don't worry about realism; allow the expressionistic approach of the dip pen to take over. Try different nibs until you find the ones you prefer.

TIP

- Don't worry about your ink smearing: Mistakes help create the romantic, expressionistic feel of the drawing. Try adding a little water to your ink for a smoother line.

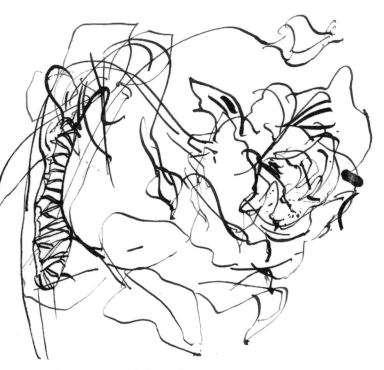

Rose, pen and ink

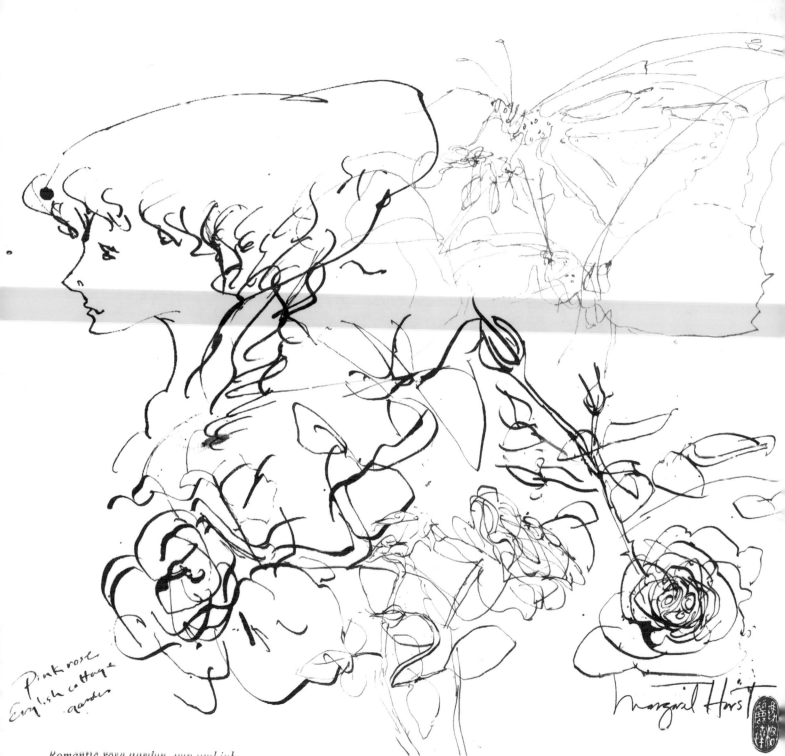

Pink rose
English cottage
garden

Romantic rose garden, pen and ink

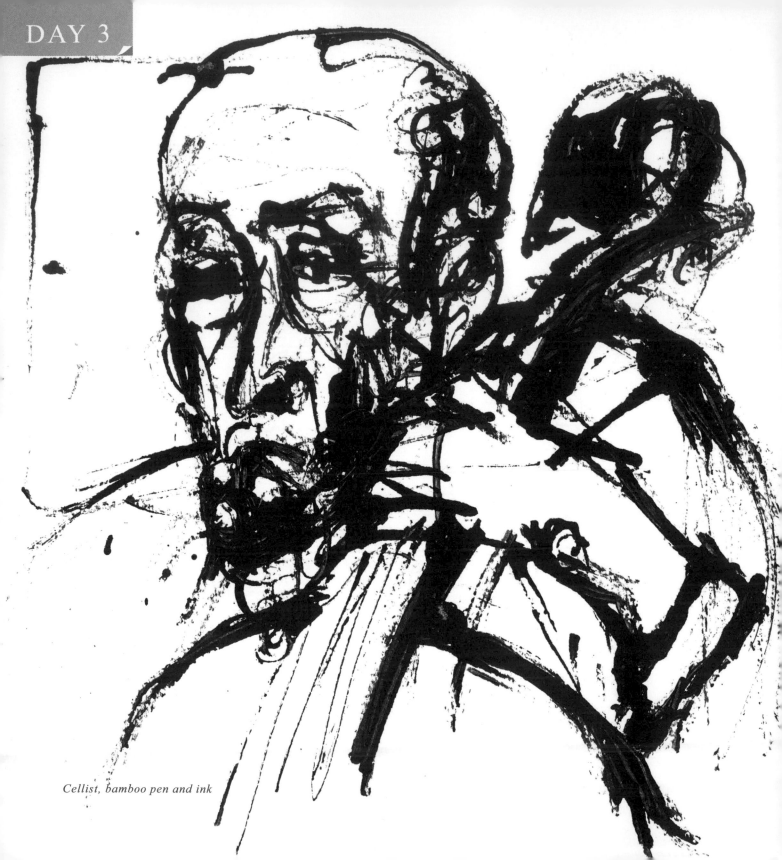

Cellist, bamboo pen and ink

Cellist

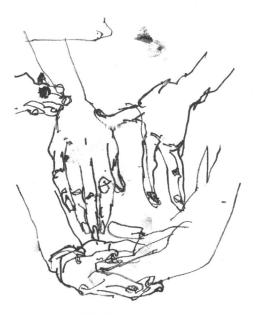

"Here is a drawing of one of the New York Repertory Orchestra cellists. The bamboo pen I used is by far the worst I've ever tried! It barely takes any ink and does not improve when sharpened, but I admit, it is kind of fun to take on the challenge and just kind of wrestle drawings out of it anyway. By the way, I really love this man's face." —Kati

EXERCISE 3

Today we are going to play with a bamboo pen—a pen made from a hard shaft of bamboo, sharpened to a point. The pen has a very distinctive graphic feel that is a good note to add to your drawing language. Using the bamboo pen and loose ink, make a drawing of someone in your immediate vicinity. Rather than draw the whole person, as we did in the first exercise variation, focus on a face, or a torso, or, as in Eddie's example at top right, a pair of hands. "Wrestle" the pen, as Kati says, and allow all the skips and blotches to become part of the overall look. Look for someone who lends himself to this kind of graphic, like the somewhat scraggly face of the cellist at left or the extreme expressions of the other two musicians Kati has drawn here.

Study of hands, bamboo pen and ink

TIPS

- Soaking the bamboo pen in water for a few hours will open up the pores and allow it to hold more ink, longer.
- Sharpen the pen with a small razor blade or craft knife if you prefer a finer tip.

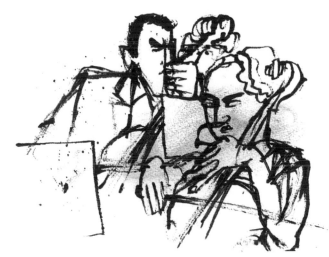

Musicians playing, bamboo pen and ink

Around the House

"This has been some week. I recently ordered a new camera [see below] and as I awaited its arrival, my computer died. As I was waiting for deliveries of all kinds, I couldn't really get out much, so I had to draw things around the house. I spent some time watching tennis yesterday and did a few drawings from the screen. It's a great way to practice when you don't have a model. This drawing at right is one that I was particularly happy with.

"Funny coincidence, both the new camera and the new computer were here on Monday evening accompanied by a new moon in the sky. I think it's time for new beginnings."
—Greg

EXERCISE 4

This is an exercise for a day when the weather, or other circumstances, keeps you indoors. Using a piece of charcoal and some paper with a light texture, draw a portrait of a person from the television. If you have a DVR, you can freeze the shot to draw from, or maybe tape it to pause and draw later. If you're feeling adventurous, try drawing the portrait in real time! You could also draw some objects around the house, similar to what we did with the still life in the first exercise. This time, use charcoal to render lights and darks and a pen line for outline and fine details.

TIP

- When drawing a portrait, look for the major shapes in the face, such as the cheekbones and jawline. This will help you get a likeness even more than focusing on the features, which can be secondary. Notice how Greg mixes soft areas of charcoal with hard line to emphasize shape and volume.

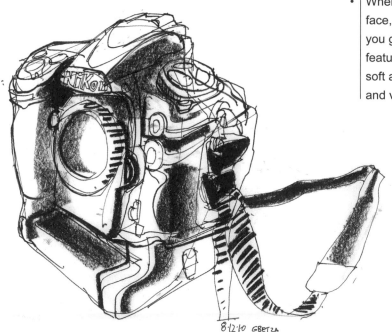

Nikon camera, pen line and charcoal

Television portrait, charcoal

*Portrait of a woman,
brush with ink wash*

Woman, Random

"Saw this woman on the train and decided to draw her with a brush pen. I don't know her; she just randomly appealed to my artistic sensibilities, so I drew her! And she definitely had a kind of romantic flair, so I felt that a brush was the best medium to capture her with. I wonder who she is and what she is doing right now?"
—Dominick

EXERCISE 5

Ask someone you know to pose for you, or take a trip out on location and find a random person who appeals to you to draw. You can use a watercolor brush and a small jar of diluted ink to draw with or buy a disposable brush pen. Test the ink color to be sure it has the amount of gray you want before making the drawing. More ink equals a darker wash, and vice versa. Allow the brush lines to dry and then overlap each other to build layers, as Dominick has done. You might look at some Chinese or Japanese calligraphy to inspire you.

Horses, ink line and wash

VARIATION

You could also try mixing the brush with a pen line, as Despina has done in this drawing of horses above. Notice the use of wash to create different values and the layering of dark marks over the lighter ones to add the spotted texture. Try putting a shape down in wash first, and then adding the line and brushwork, to avoid a "colored-in" feeling. If there are no horses handy, a pet cat or dog will do just as well!

Longwood Gardens

"'You ain't seen nothing yet!' These are the words I heard upon entering the conservatory at Longwood Gardens in Pennsylvania. The kind old man on his scooter noticed me in my state of shock and awe after seeing the beyond-words-beautiful entrance, and he felt the need to warn me about the rest of the place. He was not kidding! This place is just soooo stunningly gorgeous.

"At right is the drawing I made from the entrance. Let me explain parts of it: The cagelike structure shaped like a Victorian perfume bottle is sort of like a humongous tea infuser. But instead of tea, it holds an array of aromatic flowers, and as you walk through it, your olfactory system is truly overwhelmed. It is to scent what the Greek amphitheatre is to sound. The columns you see in the drawing are a few of the many that are covered with creeping figs and make the space feel like a fancy jungle. Everywhere you look you are confronted with the prettiest flora ever. I dare anyone to walk in this place and not feel like they've 'died and gone to heaven.'" —Despina

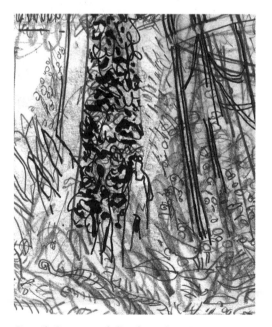

Detail, Longwood Gardens drawing

EXERCISE 6

Take a range of soft graphite pencils, from 2B to 6B, and go to a forest, field, or botanical garden near you. Draw the leaves, the flowers, the fruits, and the vegetables—draw everything! See how many different kinds of textures you can create in the drawing. Try to make different marks with your pencils—dots, scratches, scribbles—anything goes. Try the side of the pencil as well as the point for even more variation. Smudging the graphite with a stump or your finger can be fun also. Be as wild as nature is and don't worry about realism. No lines, just markings—go for expression. Once you have the feeling that you want on the page, add some darker lines for emphasis. You really want depth in this. And most important, no erasing! Allow the so-called mistakes to become part of the work.

TIP

- Any kind of paper will do for this exercise, but a nice heavier cotton paper with a bit of tooth will give you more heft and yield richer marks. Using a smudge stick instead of your finger will give you greater control of the area you want to smear. It has a nice pointed tip, unlike your index finger! Of course, you may want to mix the two for different effects.

Longwood Gardens,
graphite with ink on paper

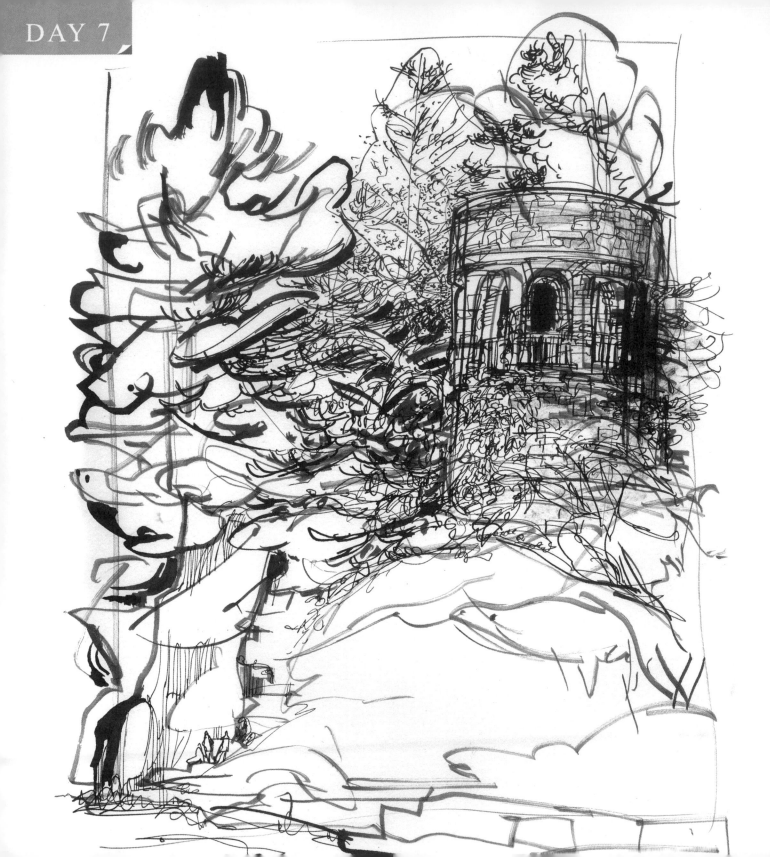

Robin Hood Lived Here

"I think Robin Hood really did live here. Or was it Maid Marian? Could this be where Howard Pyle did his famous illustrations? I saw this tower when visiting Longwood Gardens in Pennsylvania one weekend, and I couldn't help but want to draw it! Relaxing in an Adirondack chair, enjoying the nice weather, and having my husband, Neil, drawing next to me didn't hurt either." —Veronica

EXERCISE 7

This is an exercise in line and marks that combines them all, using ink. Get a few pens of differing widths, a brush or two, some black water-soluble ink, and a small jar of water. Find an outdoor scene with plenty of texture: A forest setting would be perfect. Using the pen and brush, put down some overall shapes, and then start adding marks and texture. Dip your tools in the water to gray down some of the marks as well. Allow the textures to "thread" your drawing: This means to work them so they weave in and out of the picture. You might choose a specific mark to represent the leaves on each of the different trees. Pay attention to the way that the trees overlap each other, and let the leaf marks go behind and in front of each other to create the same dappled effect in your drawing. Don't be afraid to put some nice black shapes in there and leave some areas in relief as well. This is a question of proportion—how much do you need to create the picture? That being said, don't hesitate to overdraw on this one: It's the best way to discover what works for you!

VARIATION

Once you've tried this with black-and-white line and marks, you might want to try the same scene in color. The drawing at below, left was done with watercolor and different-size brushes to allow for variety in marks and line width. Notice how marks in a black-and-white drawing can translate to color, and keep the threading idea going in the painting as well. Weave your colors and textures through the picture and create some solid-color shapes as well for relief. This variation is a good introduction to chapter three.

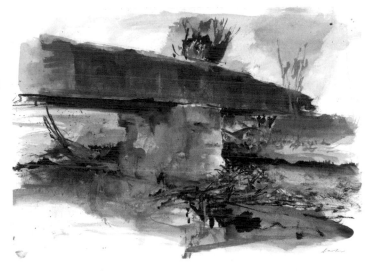

Longwood Gardens Tower, pen and ink and brush drawing, black ink, left

Bridge, watercolor painting

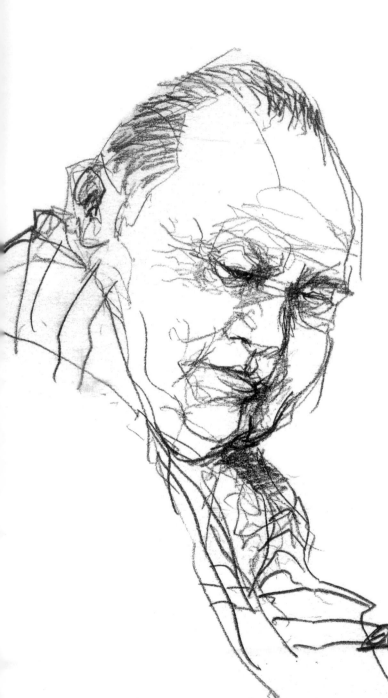

Drawings of My *Abuelo*

"Modesto Peña, that's my grandpa: He has the thousand-yard stare. I wouldn't be the man I am today without him. My abuelo [grandfather] is as close to my beginning as I will ever know. We don't have a long-lineage story of how we came to be where we are in my family.

"Modesto grew up in Dominican Republic, met my grandma, had eleven kids, and came to America. The past is not something he has ever been interested in talking about. Who he is and what he has done is sufficient." —Eddie

EXERCISE 8

Create three portraits of a family member or friend using charcoal, pencil, and ink. Choose one material for each portrait and explore the graphic differences between them. What kind of emotional effect can you get from the different mediums? Don't be afraid to smudge the charcoal, scribble with the pencil, splatter the ink: Really explore what different nuances the materials have to offer.

It's best if you can get someone to sit and pose for you rather than use a photograph. Don't take more than thirty minutes to do each portrait. A light misting with spray fixative when you are done will keep your finished work from smearing.

Drawings of Modesto Peña, pencil, charcoal, and ink

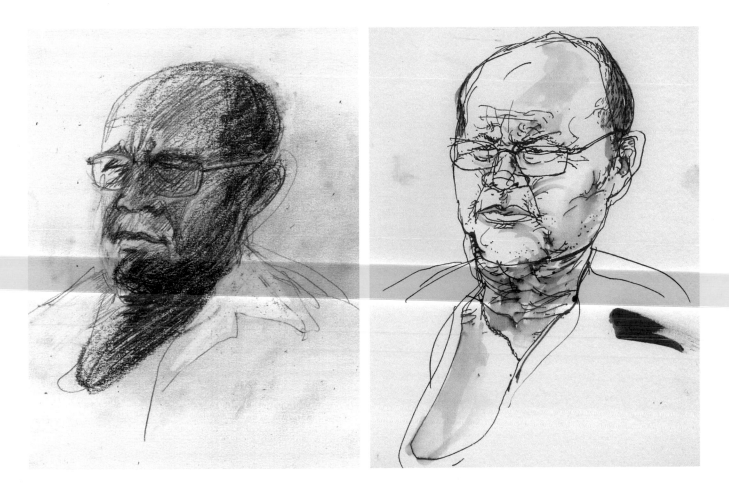

TIPS

- A smudge stick can help you get the most from your charcoal drawing, although your finger can work too. Use a kneaded eraser as well, not for correcting anything but instead to smear the charcoal or lift some of it from the paper. A stronger paper with texture will allow for more work with the charcoal. Don't be afraid to use a little pencil, too, as Eddie has done.

- Use loose ink and a dip pen for more expressiveness in the ink portrait. Don't be afraid of blotches or dribbles of ink going in places you don't want them to go: This is part of the overall feeling of ink. Explore it!
- Try different-grade pencil weights. A softer pencil such as a 6B grade will yield a soft, blurred line; a harder pencil such as a 3H will give you more sharpness. Experiment with different grades across the spectrum to see which feel works best for you and best describes the personality of your portrait subject!

Central Park boathouse, by Despina Georgiadis, pastel

Chapter Three:
PLAYING WITH COLOR

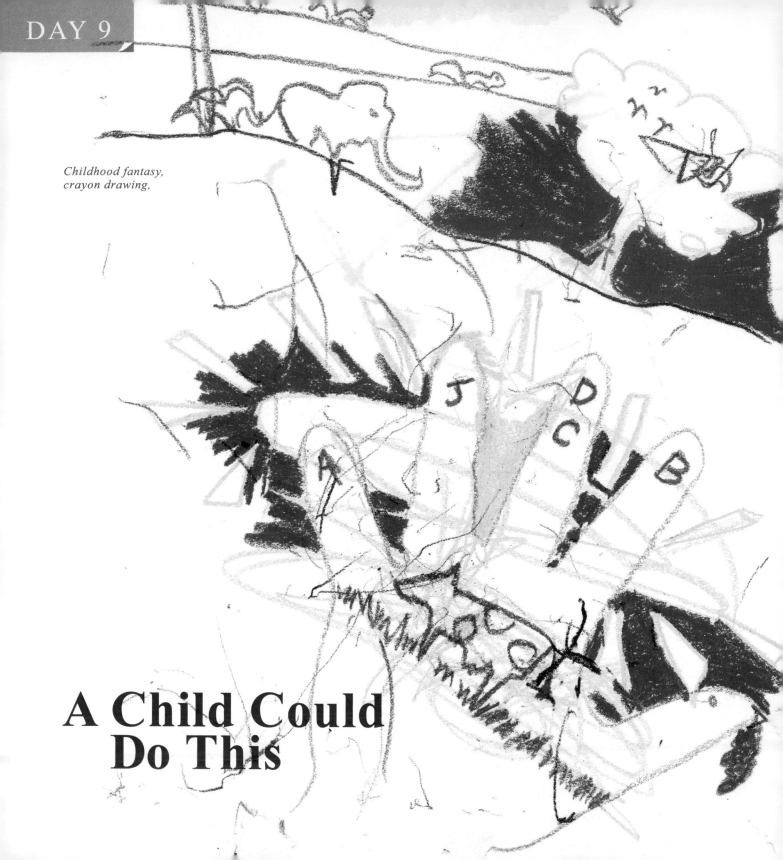

*Childhood fantasy,
crayon drawing,*

A Child Could Do This

"But she didn't, she only art directed. Actually, my daughter Anastasia did draw a little of this. I gave her my sketchbook and asked her to trace her hand. She said, 'You do it,' and then proceeded to put yellow scribbles around my hand's outline. That was all the heavy artwork she was prepared to do. After that, she rattled off the letters I should draw: a for Anastasia [her name], j for Joanna [my wife], d for Dominick [me], and then b and c because they come after a. Anastasia then looked out of our window at the squirrels and directed me to put some into the drawing, as well as birds and an elephant. The exercise lasted about 10 minutes. My daughter got nothing from the experience but supervisor training and she still tells me what to draw, but at least we have developed a good working relationship. Oh yeah, she chose the colors too." —Dominick

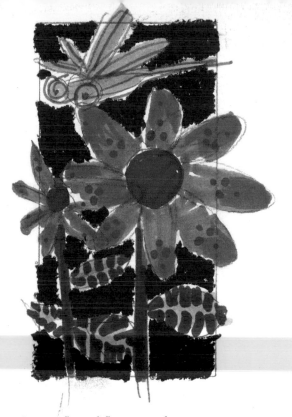

Dragonfly and flower, markers on paper

EXERCISE 9

Get yourself a big piece of cheap paper and a box of crayons. If you want to, go for the sixty-four-color Crayola special box with the sharpener in the back, but any kind of child's crayons will do. This exercise is our introduction to playing with color. And the key word here is play.

You can ask a child to tell you what to draw or simply channel your inner child. To begin, trace your hand with a colored line and then decorate it. Add letters and numbers. Think of symbols that you liked when you were young: stars, hearts, cars, flowers, animals, animated characters—anything goes. Create some lines with color and make some solid shapes as well. Relax and remember the feeling of playing with crayons that you had when you were young. Pick any color at random; don't worry about which color is right, good taste, or good design. Just grab 'em and get busy! Don't forget to include a decent amount of scribbling—it's good for you. If it helps you to get in the mood, have some cookies and milk while you do the exercise.

VARIATION

Now that you are feeling a little bit freer with color, get some nice, thick colored markers and try a bold picture like the brightly colored drawing of flowers and a dragonfly that Eddie has done. Pick a still-life subject with big shapes of color. Start by drawing the lighter shapes and overlay them with darker shapes and patterns. Try dots, dashes, checks, scribbling. You might incorporate a crayon or two into the drawing as well, but don't overcomplicate it. Just play around with the richness and layering of the colors. Have fun!

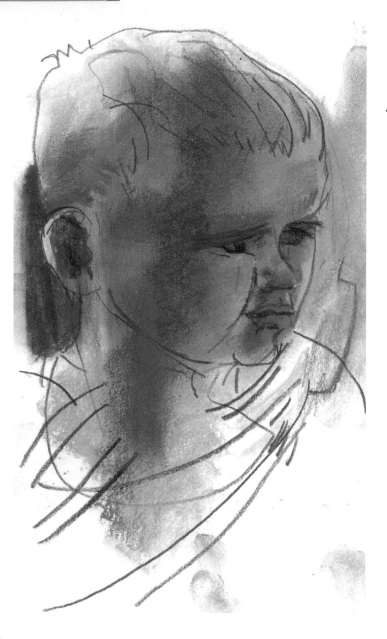

James, pastel and colored pencil on paper

Color Study

"My son James and I hang out together a lot. Every once in a while as he plays, I see some funky-looking light fall upon him. So I grab my crayons and I play, too.

"Sometimes I like to find the light when I draw. I try to see how it changes the things it touches. And then the challenge for me is to find a good combination of colors that can explain what I'm seeing and feeling. I tried it again with a portrait of my mother." —Despina

EXERCISE 10

Now that you've played with color a bit, let's try a color portrait.

Color is light, energy. Despina looks for a special kind of "funky" light that gets her excited to draw: What kind of light do you find the most beautiful? Whatever time of day that is, ask a friend or family member to pose for you at that time. Using pastels and colored pencils, create a portrait that reflects the feel of the light that you've chosen. As with the work Despina did here, allow yourself to go beyond the confines of what the color actually is and move toward how the color actually feels. Don't be afraid of vibrant colors: Play around with crazy combinations to see what results you can get—you may find them closer to reality than you expect!

Mama, pastel and colored pencil on paper

TIPS

- Try to find the large shapes in the face and put them down with color in a bold way. Let the pastel colors define the shapes and use the colored pencil for line and details.
- It sometimes helps to draw someone who is an artist or a fan of your work—people get tired of posing very quickly!

Colorin' with Water

"What better way to say goodbye to summer fun than spending time colorin' with water down at New York City's South Street Seaport? The sun was hot, the coffee was iced, and the color was flowing. It's wonderful to make art." —Michele

EXERCISE 11

Get a set of watercolor pans and some watercolor paper and head out to your favorite urban hangout. Michele picked a seaport, but any place you like to visit will work. If you live in a small town, think about going to the town square. Pick a scene that offers a few views, so you can paint more than one.

Without drawing a pencil outline, pick a view and paint some solid shapes that you observe, directly with the watercolor. Put enough water on your brush to saturate the pans of color, but not so much that you lose the ability to control the shapes as you paint them.

Start with the lighter shades and add the darker ones on top. Pay attention to textures and patterns that can form strong picture shapes as well. Be patient and allow each layer to dry before you add more color over it. Allow the scene to build up naturally; that's the idea of doing more than one drawing at the same time. While one of them dries, you can work on the other one.

Don't be afraid to incorporate people into your scene—keep them as simple shapes in design as Michele has done with these. You might even turn the final paintings into postcards for your hometown!

Woman at the seaport, watercolor

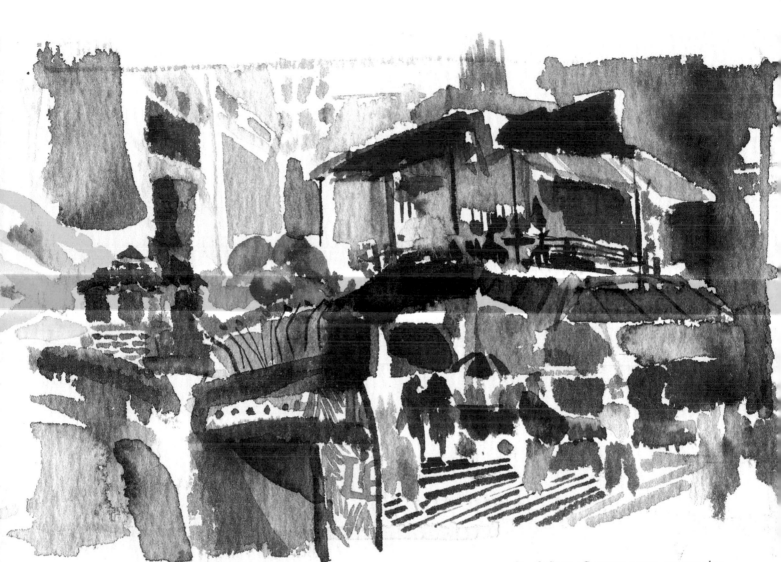

South Street Seaport scene, watercolor

TIPS

- Try using a thin brush with color to create some linear effects.
- A watercolor block will keep the paper stretched and flat while you are working, as opposed to loose sheets of paper.
- Use a sable-haired brush for greater sensitivity. It will also hold more paint.

Sacré-Coeur, monoprint of water-soluble crayon drawing

Thinking of France

"Something always makes me think of France. Drawing at the Basilique du Sacré-Coeur was an experience that has stayed with me over the years. The basilica of Sacré-Coeur, which means 'sacred heart' in English, sits on the highest point of Paris, at the top of Montmartre. The Montmartre district of Paris was the home to many famous artists, among them Pablo Picasso, Vincent Van Gogh, and Amedeo Modigliani. I can see why they liked living here—this district is a very romantic must-see for any artist visiting the city of light!" —Dominick

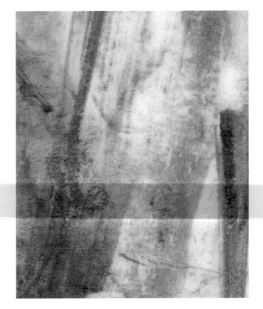

Sacré-Coeur, detail

EXERCISE 12

Create a monoprint of a local landmark. You will need a stack of watercolor or other absorbent paper, a spray bottle filled with water, and several water-soluble crayons. Bring a range of color that seems like it will be aesthetically suited to the place you plan to visit. Don't worry so much about the actual colors of the place—by selecting them before you go you will be true to the impression that the landmark has left on you.

Working quickly, create an impressionistic drawing with the water-soluble crayons, spray it with water, and press a clean sheet of watercolor paper on top. Smooth it out with the palm of your hand to be sure you are making good contact. Experiment with different colors and different amounts of water: Don't hesitate to draw into the print with the crayons after you've created it either. You might even try this on different surfaces to experiment with other textures. Work to get the feel of the landmark that you've chosen. When you're finished, be sure to sign your one-of-a-kind print!

TIPS

- It can be interesting to add other materials to the printing process—leaves and scraps of paper can create some unusual effects when printing.
- Using the side of the crayon will give you bold strokes of color.

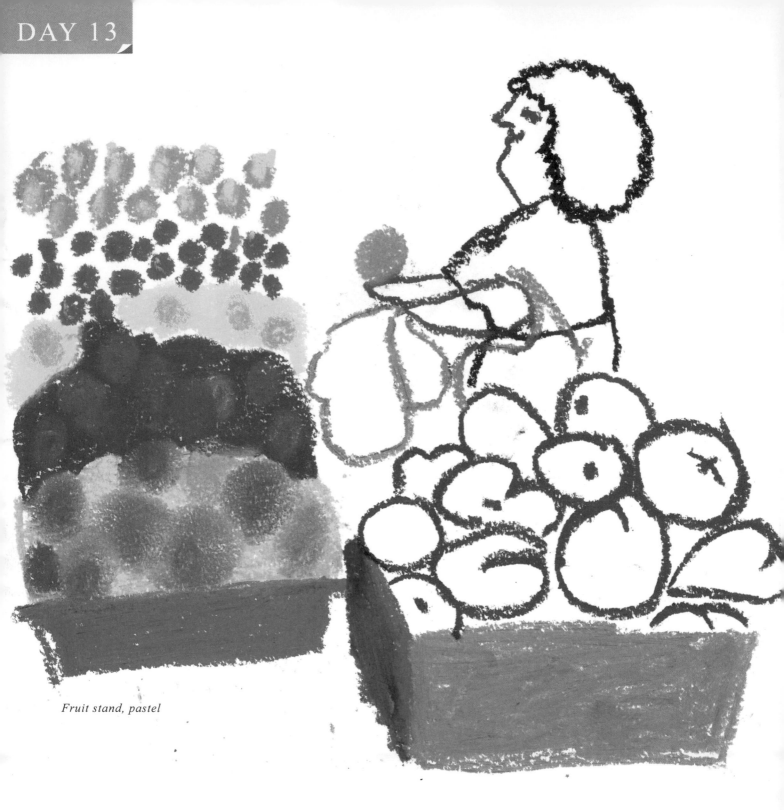

Fruit stand, pastel

Line as Color

"This little drawing is of dogs socializing at the Bethesda Fountain in New York's Central Park. You really know spring is in the air when dogs start appearing en masse at the city's parks as the perfect accessories for their owners." (New Yorkers are their own breed.) —Kati

EXERCISE 13

For this exercise, we are going to make a line drawing with color. Pick a spot where you like to draw. It could be a location, such as a dog park, or a still life you set up in your own home. This exercise can be done with any subject.

Using pastels, colored pencils, or crayons, create a line drawing using a minimum of five different colors. Notice what color choices feel right as opposed to being overly influenced by the colors that exist in the scene. (Or you could choose them totally at random, as Kati did when drawing the doggies in the park.) The idea is to do a drawing as you would with a black line, substituting colored lines instead. This is a good exercise for developing your individual taste in color.

VARIATION

You might try an additional color drawing that includes a few solid shapes of color with the line, as Kati has done in her drawing of a California fruit stand, left.

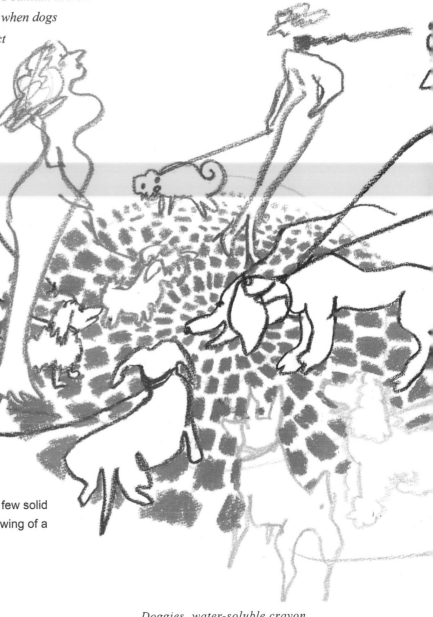

Doggies, water-soluble crayon

Central Park spring colors, watercolor

The Park

"Here is a watercolor I made at Central Park in the springtime and one I made in fall, with the changing colors. In the fall one, some of the trees were still green, but many of the leaves had begun turning into intense and beautiful colors. Fall is such a brief time to be happy before everything turns gray and white." —Greg

EXERCISE 14

Find a group of trees or shrubbery with nice full shapes to
work with. Set up a piece of watercolor paper and squeeze
some color down on the page, using the shapes of the
shrubbery as a rough guide. Use undiluted paint from tubes
(rather than pans) and put the greatest concentration of paint
in the area where you want the most vibrant color. Then,
using a wet brush, bleed the color out from there. Work
directly with the paint; don't pencil anything in first or mix
the paint on a palette. Use some thick brushstrokes for lines
and rough in shapes; let the colors flow one into the other.
Think about creating an impression of the scene in front of
you rather than strict realism.

Create two versions. In the first, choose one color that
dominates the scene and practice using different shades of
that color. In the second version choose colors that would
represent a change of season or a change of weather, such
as autumn or a rainy gray day.

TIP

- Create greater depth with transparency: That is the most
 unique feature of the watercolor medium. Add a significant
 amount of water to your pigment, apply, and let dry. Once
 the area of color is dry, paint over it with the same color to
 create a deeper value or choose another color to see how
 the two mix. Watercolor paper works best for this exercise.

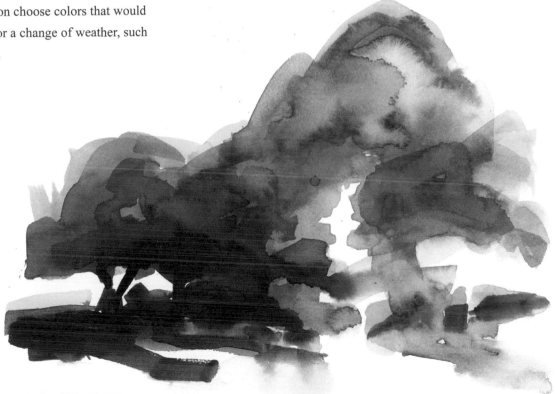

*Autumn in Central
Park,* watercolor

Bountiful Harvest

"Whew! When this drawing was done, I had just returned from a month of traveling and finally unpacked my suitcase. Spent some time in Barcelona with my husband, Neil, then traveled to Paris with the Dalvero Academy and eventually wound up my travels by going to Portland, Oregon, as a presenter at the 1st Annual Urban Sketchers Symposium! The drawing below was made at the farmer's market in Portland, so I've called this exercise 'Bountiful Harvest.' Meaning, to explain, the harvest of all kinds that reportage drawing

Bountiful harvest, watercolor, pastel, pencil

and illustration has brought me: my old friends and dearest Studio 1482 family, the wonderful group of artists who study with Margaret and me at the Dalvero Academy, and the new friends and sketching enthusiasts from around the world that I met in Europe and at the Urban Sketchers Symposium. Not to mention the joy I get every day from doing what I love, drawing. What a bountiful harvest indeed!" —Veronica

EXERCISE 15

This is an exercise in mixing several different mediums and proportions of color. Use watercolor, pastel, and colored pencils.

Go to a farmer's market near you, or if you don't have one, visit a local produce stand in your town. Choose a spot to draw that shows a wider range of color. Working quickly, lay down some shapes with the watercolor, then add to them with pastel. Add some solid line with the colored pencil for detail and work back into the drawing with the watercolor and pastel again. Add more line if you think it's necessary or use the pencils for specific detailed marks. Work fairly quickly and keep it loose: Notice how I have kept the shapes half open and worked the spaces between foreground and background. Don't be afraid to mix colors in new ways: You want an overall impression of what you're drawing. Keeping the shapes from closing entirely will give the drawing a sense of life and vibrancy. Of course, you will need to draw one or two shapes completely so the viewer can fill in the rest in their head!

Poppies, colored pencil and pastel

VARIATION

You might try a mixed color drawing that emphasizes line over shape, as I have done with this drawing of poppies, above. Make your line drawing with colored pencils, and then add a bit of pastel or watercolor, or both, in a limited amount. This creates unusual proportions and can be a nice variation to the piece with heavy emphasis on color shapes and marks.

Carousel Painting/Drawing

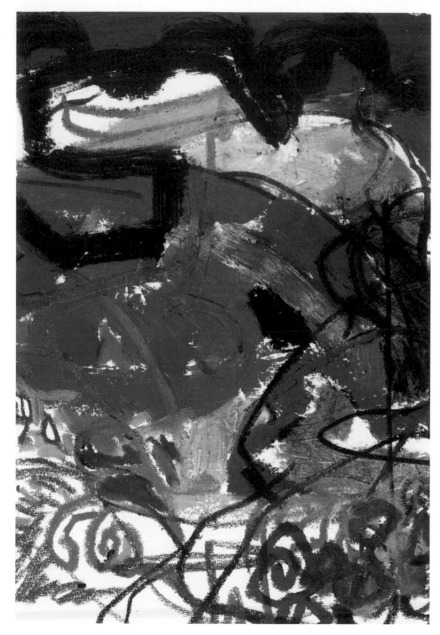

Detail, carousel

"What was happening the day I did this carousel drawing is that I just wanted to play a little with all the colors and the shapes that surrounded the actual horses that made up the carousel. And of course, when I went to draw them, the carousel was moving, and so I saw the art as more motion and color and line than as a traditional carousel drawing/painting. So all of the color and activity surrounded the horse, and he became the means of identity to the carousel. It was just fun to approach it that way!" —Margaret

EXERCISE 16

Today we are going to take color drawing into painting, as Margaret has done with this lovely expression of a carousel.

Find a spot that is loaded with color. It can be a fantasy, such as a carousel, or something more grounded in reality, such as a flower market. Whatever place you choose, make sure it has more colors than you can count! Using a mixture of oil-based grease crayons and water-soluble crayons, create a vignette of what you are looking at, on the spot. A vignette is a picture that forms its own borders and is

*Carousel, oil and
water-soluble crayon*

usually an irregular
shape. Use the crayons
to create lines, solid
shapes, and markings or
textured patterns. Layer the
color and get abstract, as Margaret has
done. Notice in the detail at left how a
piece of the whole looks like an abstract
expressionist painting! The key is to
make a bit of a mess of the color and
enjoy the process.

How much information do you need to
keep the picture clear?

TIP

· Look for an overall shape that you can
anchor your work to. Pulling out
identifying details with line will keep the
subject of the vignette from becoming a
total abstraction.

Chapter Four:
PEOPLE WATCHING AND CAPTURING MOTION

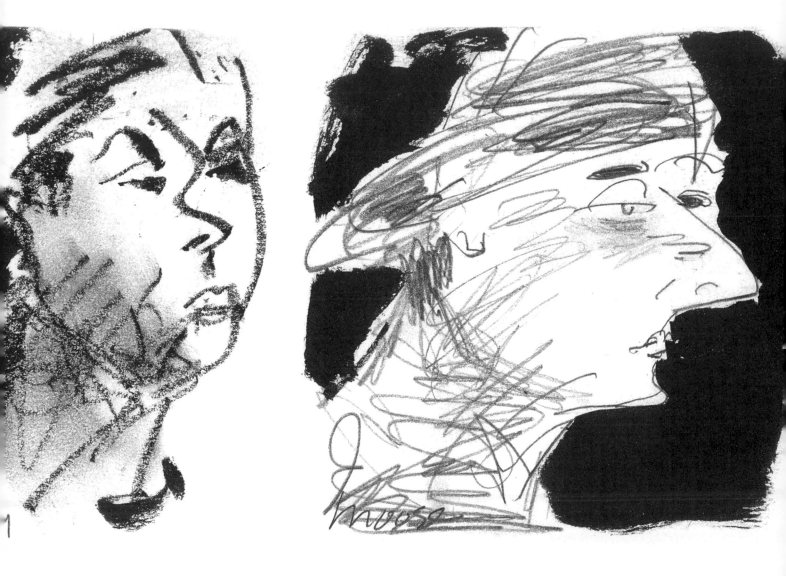

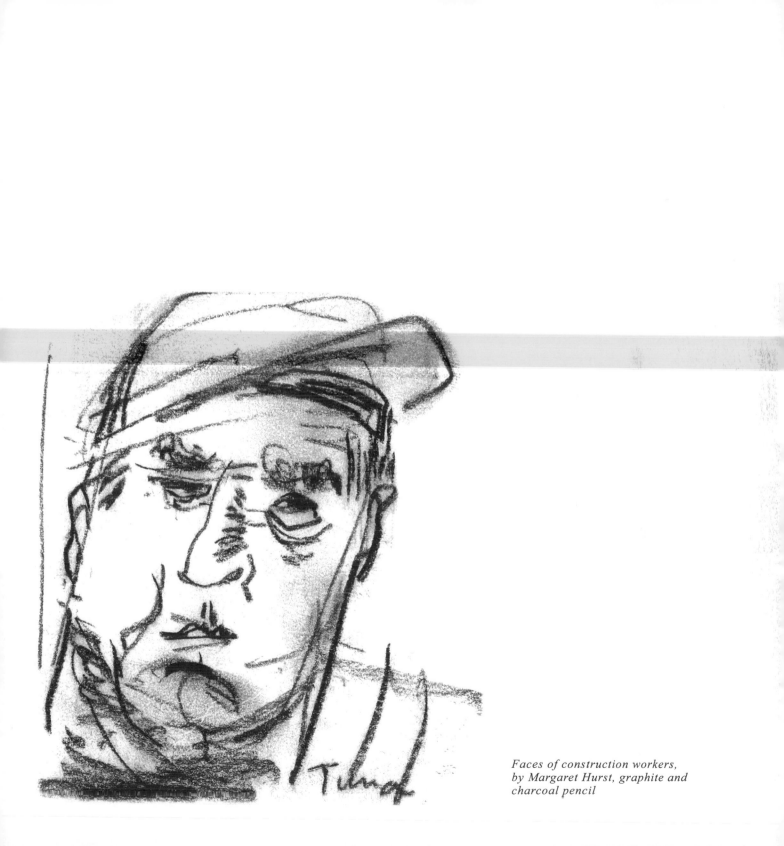

Faces of construction workers, by Margaret Hurst, graphite and charcoal pencil

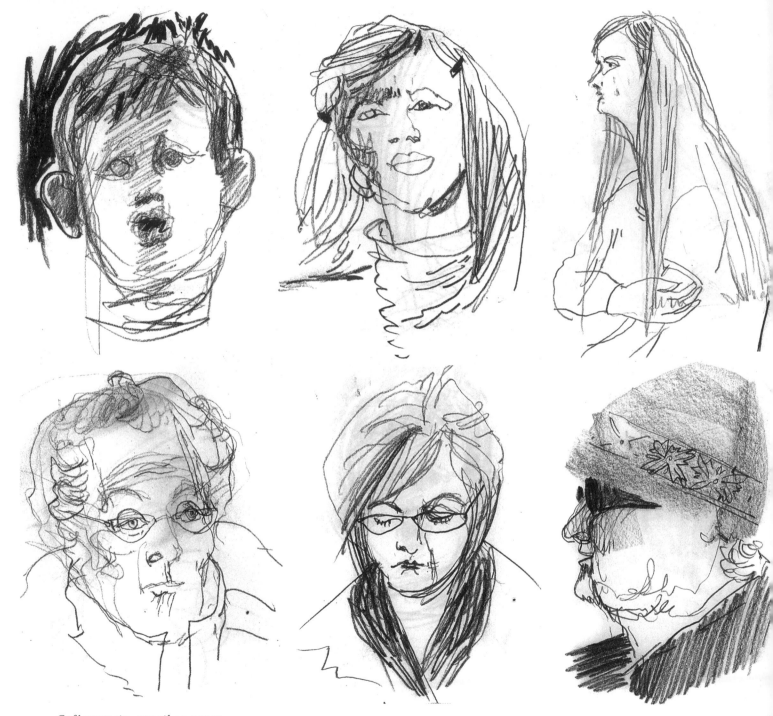

Café portraits, pencil on paper

Faces

"I spent the afternoon at a Barnes and Noble bookstore the other day. During my break for coffee at the Starbucks café, I made some drawings of the people around me. Clockwise from top left: the whiny kid; the satisfied customer; the shy girl waiting to order; the eccentric dude; the quiet reader; the old woman in a wheelchair." —Despina

EXERCISE 17

Go to a local café and find a good seat. Order yourself a coffee, or latte, or whatever you like to drink, and open your sketchbook. Using a range of pencils, draw portraits of the other patrons at the café. Think about how to show their personalities as well as get their likenesses down. Despina draws body language and uses graphic markings to describe the feeling that each person gives her. The whiny kid has a lot of agitated marks on his face; the satisfied woman has a smug expression; the shy girl is hugging herself; the eccentric dude is hidden by his glasses and the shape of his hat; the quiet reader is looking down, and the marks of the drawing amplify that direction; the old woman in a wheelchair has curly lines all over.

Observe people's expression and body language and play with different kinds of marks in a similar way to show personality. Have fun, and if someone catches you drawing them, smile and show off your work of art!

VARIATION

Instead of drawing anonymous people at a café, you might try making a drawing of a "local legend:" someone who is famous in your town. For example, in this drawing (below) Greg has drawn a man known as "the Gentleman Peeler." He was well known in New York City's Union Square Park as a salesman of vegetable peelers who took his work very seriously! A drawing like this can become part of the oral and social history of a town.

The Gentleman Peeler, pencil drawing on paper

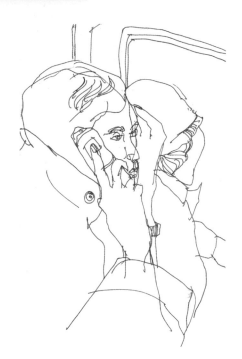

Commuter on cell phone, pen line

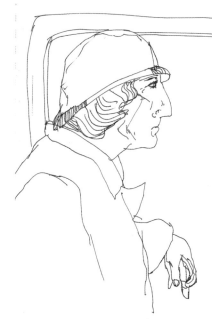

Annoyed commuter, pen line

Sign Language

"These two people were so much fun to draw. She was talking with her mouth and her hands. He was trying to say something but couldn't get a word in edgewise. She was talking with one hand going in the air and the other hand running back and forth across the tabletop. It was like sign language with simultaneous interpretation!

"This was the moment when he finally dared to open his mouth. It didn't stay open too long! You can see the frustration in his arched eyebrow. Trés cool!" —Margaret

EXERCISE 18

Go to a café or place where people gather and draw a couple of people having a conversation. Pay close attention to their expressions and their body language. See if you can't figure out what the conversation is about through your observation.

Don't be afraid to draw things multiple times as Margaret has done with the lady's hand at right. This creates a sense of motion in the drawing.

VARIATION

Action/reaction: Find a place with a lot of people, such as a train or a bus, as Margaret has done in the two drawings at left. Look to see if someone is doing something, such as speaking on a cell phone or eating loudly, which is creating a reaction in another person. It could be something nice as well, such as a musician performing in a public space and an enthusiastic admirer. Really observe facial expression and body language and mark them down in your drawing.

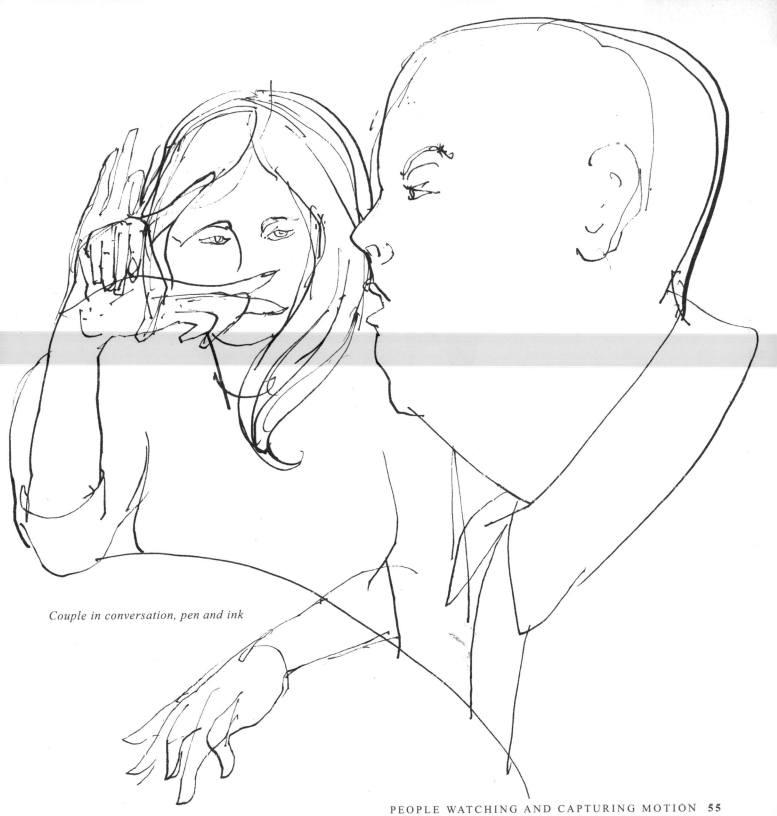

Couple in conversation, pen and ink

Music Lovers

"This is a drawing of some ladies listening to traditional Irish love songs. Their love for the music was obvious. As a music lover myself, I was touched by that, though I could not help but indulge a little in drawing their odd shapes!" —Kati

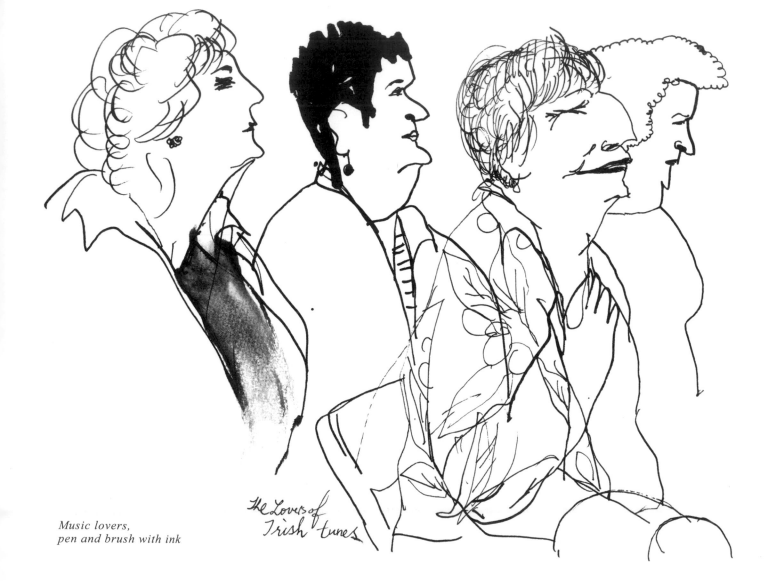

Music lovers, pen and brush with ink

EXERCISE 19

Today's exercise is all about the profile! Go to a place where there will be a lot of people facing in the same direction for an extended period of time, such as a music concert, a line for a show, or some kind of convention. You might even do this while riding on a train or airplane.

Using a portable fountain pen, pencil, charcoal pencil, or brush pen, or a mix of all of them, create a series of simple profile portraits of the people you see. Notice the differences between the various people and don't underestimate the importance of body language.

Some people keep their chin down, others have their nose in the air, while others keep themselves looking straight ahead at all times! Combined with the position of the shoulders and back, the profile body language can reveal quite a lot about a person's emotional state of mind.

TIPS

- Don't be afraid to exaggerate the features of the profile you are drawing, as Kati has done in the drawings at left and below.
- You might even seek out people with large noses and unusually shaped faces; they are often the most fun to draw!

*New Yorkers,
brush and ink*

Spectators

"This is a drawing I made of the spectators at the annual Greenwich Village Halloween parade in New York City. You can see that some of the people are watching the parade, some are watching the watchers, and some seem to be having a cocktail on a New York City bench. It's really a very relaxed, easy scene: what used to be called 'groovy.' I enjoy going to draw these kinds of public events not only for the main issue, such as the parade, but for all the practice I get from drawing the onlooking crowd!" —Veronica

Parade spectators, pen and ink

EXERCISE 20

Go to a place where there is sure to be a crowd of people. If there is a parade in town, terrific; if not, you can go to your local shopping mall. Select a spot where people gather, such as a bench or waiting in line, and make a drawing with a fountain pen. You can use a dip pen and bottle of ink, if you prefer, for a bit more flair to the line.

If you'd like, use water-soluble crayons to create a color drawing, such as the one Greg has done at right. The main thing is to look for the body language of the people and at how the crowd has a shape of its own. Don't find yourself drawing each person separately: Notice how one shape of a person connects to the other. Create a scene consisting of mainly people; at least five would be good to start. Add a little bit of background for context. You could mix the line and color too, if you prefer.

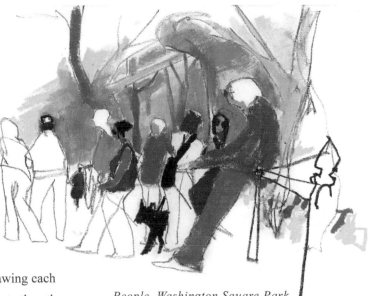

People, Washington Square Park, water-soluble crayon

TIP
- It's a good idea to carry a small sketchbook and fountain pen in your pocket or purse so as not to miss opportunities to practice your drawings of people. Michele made this lovely drawing of movie patrons looking for seats, below, while waiting with her husband for the feature to begin.

Movie crowd, pen and ink

A Good Day for a Song

Barbershop quartet, pen and brush and ink

"I figured it was a good day for a song. Something traditional. A classic: easily sung along with. This drawing that I made of the barbershop quartet at Disney World reminds me of a perfect Saturday afternoon spent listening to some good old classic melodies and hanging out with friends." —Dominick

EXERCISE 21

How do you capture music, and musicians, on paper? Only one way to find out—by drawing them! For this exercise, visit a local church choir, your son's garage band, a local orchestra in rehearsal or performance: You get the idea. While there, make a drawing or two of the musicians doing what they love, performing. Try to work with a type of music that resonates with you. Dominick enjoys the old-fashioned American sound of the barbershop quartet and chose to draw them with a dip pen and brown ink on cream-colored paper, to get both the expression of the musical feeling and the light sepia tone we often associate with "the good old days."

Think about what mediums best represent the graphic expression of the feeling the music gives you. It's a good idea to bring an assortment of materials with you on location to do this exercise, as you may not be aware of what type of medium feels like the music until you hear it!

Café musicians, pencil and marker

VARIATION

You might try picking two separate musical genres to see how you interpret each graphically. What are the differences between the sounds of the two musical types, and how do those differences affect the type of materials you choose to draw with, and the speed of your drawing? Drawing has pacing inherent in it: If you draw faster, you'll get a different feel than if you draw more slowly. Dominick's drawing at left has a quick, upbeat feel to it that reflects the music he is hearing while working; Greg's drawing of a gypsy jazz café group has a slower, more deliberate pace that reflects the sinuous sounds of the café scene.

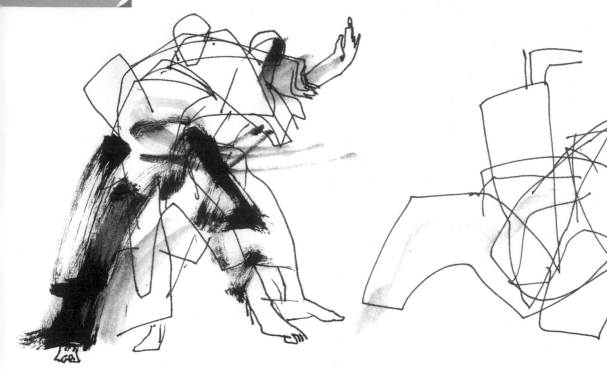

Long Island Aikikai

"I had another fun evening recently drawing my husband, Neil, and his fellow aikido practitioners at the Long Island Aikikai dojo. It's fun to try to capture their moves on paper and, I think, a much less strenuous way for me to participate!" —Veronica

EXERCISE 22

Go to your local gym or YMCA and ask to draw during one of their classes. Any sport that involves two opponents will work for this exercise: aikido, karate, wrestling, boxing; even a sport such as tennis would be perfect. Using portable materials such as a razor-point disposable pen and brush marker, draw the opponents while they are engaged in their sport. Keep your eyes on them while you draw and try to follow their movements with your pen. You might use the brush pen for bolder lines or shapes that can help identify what's going on. Don't worry about likenesses or tight details: Simply go for the overall movement and feel of the athletes. Take advantage of repetitive movements to work on parts of your drawing more than once. And keep far enough away from the action so you don't get kicked!

VARIATION

Try making the drawings with color for an additional challenge. A portable combination of mediums such as the colored pencil and pastels that I use here keeps your drawing quick—and no spills! Think about the shapes between the athletes as something that can be drawn as well as the athletes themselves. You might use a softer medium such as pastel for movement and a harder medium such as colored pencil for details that you want to incorporate. Or you might use many lines for movement and the soft material to block in shapes. Experiment to see what works for you.

*Aikido practice,
pen and brush*

Aikido opponents, pastel and colored pencil

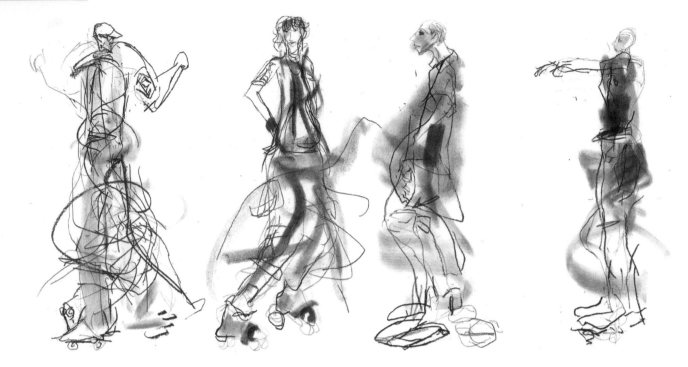

Roller skaters in motion, ink and PanPastel

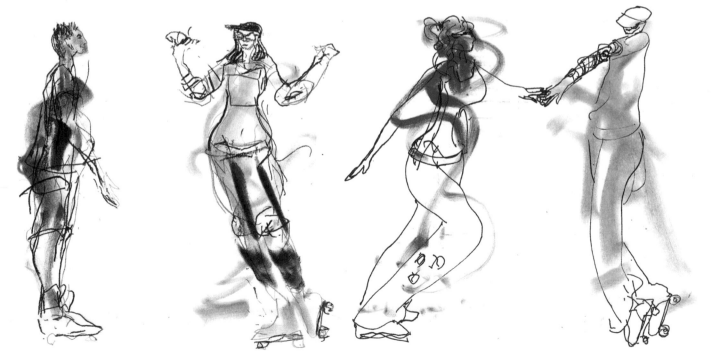

Skaters in Motion

TIP

- Try putting a different medium in each hand for more expressiveness. Having color in one hand and black line in another will help you to capture not only the movement, but also the detail and visual information you need to communicate.

"I have been making drawings of the Central Park Dance Skaters Association skaters, in Central Park, for about two years now. I love following their movements, and it's exciting when they go wild, which happens a lot! They can't seem to help themselves; they just have to go a little nuts now and then. I'm more than happy to be there, watching and drawing them when it happens!

"This time, I decided to draw the skaters with two hands simultaneously. It felt more comfortable to me than drawing them with one hand: I could accomplish more with a two-handed drawing than with a one-handed drawing! You can capture the essence of the body movement quicker and more succinctly. I also used my PanPastel colors—what a delightful way to spend the afternoon." —Margaret

EXERCISE 23

Draw with two hands at the same time. Find a group of active people: dancers, skaters, bikers, or joggers. Lay your paper down on the ground and situate yourself so you're over it. Look at the people and, without looking down at your paper, draw with two hands at the same time. Keep both hands moving and keep them drawing in separate areas of the paper. Trust your instincts and you just may be surprised at what happens!

Spinning skater, charcoal pencil

Chapter Five:
CLOSE TO HOME

First Day of Snow, by Michele Bedigian, charcoal pencil

Home Garden

"Those who know me and know my work will recognize the theme of the garden as a metaphor for paradise [home]. I remember eating strawberries, gooseberries, currants, plums, peaches, apples, and hazelnuts directly from the bush as a kid playing in our home garden. This page is part of an ongoing project on the history of feminism—notice the woman busy working the earth. It also makes me want to start a victory garden and eat freshly harvested collard greens!" —Kati

EXERCISE 24

Pick up some richly colored pastels and create a drawing of your home garden. If you live in an urban area, you might find out where there is a public garden you could draw in; most cities have at least one. Let the richness of the pastels affect your drawing. Look for color shapes and keep the design somewhat simplified, as Kati has done. You may or may not want to include the gardener! Choose a nice sunny day so you can experience the feeling of being in the middle of nature. Keep it loose: No need to get into a lot of tight details. Look at the broad shapes of the plants and put them down, then add leaf or vegetable shapes on top of that. It might make sense to start with the lighter colors and then build the darker shades on top. Feel free to use a cheaper white paper if more expensive textured paper inhibits you. The idea is to play with the pastels and experiment with the result.

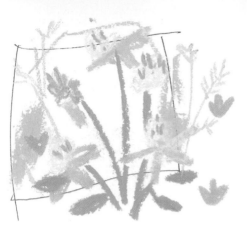

Clover, pastel

VARIATION

Try drawing individual plants. Use the pastels for line, shape, or a combination of both. Find out the names of the plants you're drawing. If this is your own garden, these drawings might make nice tags to attach to produce that you give to family and friends.

Again, the key to this is playing and not worrying about the artistic outcome. Just relax and enjoy an afternoon spent in a garden.

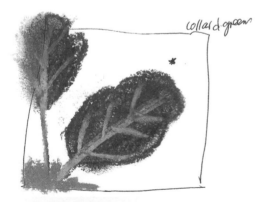

Collard greens, pastel

Garden and strawberry plant, pastel

Childhood
garden

Woman's
World

Rocks

*"Here is a drawing I made of my son playing in
our backyard with his favorite toy, rocks."* —Greg

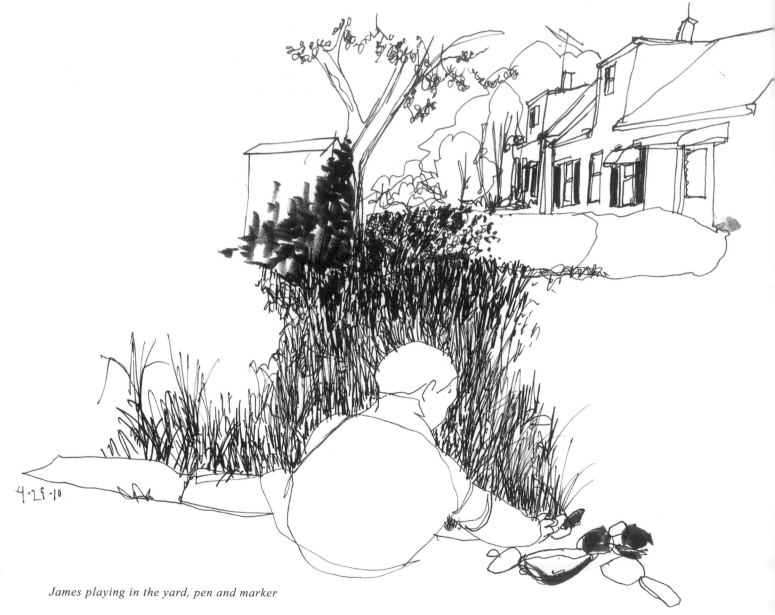

James playing in the yard, pen and marker

EXERCISE 25

Everyone takes a million photographs of children, especially in those first five years when they are growing and changing so rapidly. Why not create drawings of the little ones instead? What a beautiful and sensitive way to remember this special time in their lives.

For this exercise, make a drawing of your young child at play. Use a fountain pen or razor-pointed marker and/or a brush marker for both speed and clarity. After all, you need to capture the scene quickly, before nap time rolls around! It would be nice to include the context of where your child is playing, as Greg has done with his backyard in this illustration. If you are not a parent, or your children have grown, draw a friend's child or a niece, nephew, or grandchild! A drawing such as this makes a wonderful gift.

VARIATION

For a variation, you might choose to draw the child when he or she is asleep or in a quiet mood, as Eddie has done at right with these two drawings of his children. Having a quieter subject to work from allows you to slow down the pace of the drawing. You might try using charcoal or a Conté crayon, for more sensitivity with this approach.

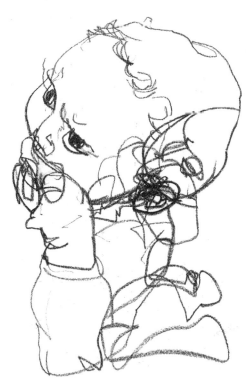

Noah, charcoal pencil

Aryanna sleeping, charcoal pencil

Clouds

"I love the clouds in Florida, in the southern United States. They feel kind of spiritual to me, and from another world. I did these cloud drawings for an animation project that I have had under the bed for a long time. I made them while driving [I was in the passenger seat], so in addition to the horizon changing rather quickly the clouds were also changing form as we drove along. I just kept flipping the page and drawing the clouds to capture how grand they were." —Dominick

EXERCISE 26

Today is an exercise in relaxing, daydreaming, and drawing the clouds! Choose an appropriate day, weather-wise, and take your pad into your backyard or a local grassy area. Bring a fountain pen and paper with you, as well as a blanket. Lie back, look up at the sky, and make a few thumbnails of the pictures the clouds present to you, as Dominick has done here. If you see images in the clouds, jot them down, or you may simply enjoy the abstract shapes they create.

Cloud thumbnails, pen and ink

Color clouds, watercolor and pastel

VARIATION

You may choose to bring some color along on this trip as well.
Try a mix of watercolors and pastels to help capture that
floating, yet very solid, feeling that the clouds often have. It
would be interesting to see how the clouds from your home
compare with the somewhat dreamy clouds of the south-
eastern United States!

Bowl of Veggies

"Harvesting my garden is really a lot of fun. The whole family gets involved in picking the vegetables, and then we sit down for dinner. The experience is lovely.

"Here is a study for a painting of a bowl of freshly picked veggies: string beans, tomatoes of all shapes and sizes, cucumbers, squash, and a purple pepper on top." —Despina

Still life of vegetables, watercolor, colored pencil, and pastel

EXERCISE 27

Go into your garden, or your refrigerator, and pick out a nice selection of fresh fruits and vegetables. Arrange them in a beautiful bowl and get out your colors.

Use watercolor, pastel, and colored pencils to make this drawing. Try drawing some rough shapes with the colored pencil, painting some large color shapes with the watercolor, and then adding the pastel for heft. Work back and forth between the pastel and colored pencils; there are no rules to this. Mix colors to see what effects you get. Sometimes, putting opposing colors of the color wheel against each other can create a vibrant feel.

Pick your colors by mood as much as by looking at what's in front of you. Just because a tomato is red doesn't mean you have to draw it that way—think of the multiple colors that Vincent Van Gogh used in his paintings. If it was good enough for Vincent, why couldn't it work for you?

A thicker piece of paper will stand up to the pastel, but try one without a lot of tooth so you can get a smoother color down. Layering the colors adds depth; if you spray fix your drawing midway, you can add more layers of pastels and pencil. Don't be afraid to overwork it; the idea is to discover what assortments of shape, line, and overlays work for you. Making a little ratatouille when you're finished drawing might be a nice idea, too.

VARIATION

You might also enjoy trying a little abstraction with your bowl of fruits and vegetables, as in my drawing of mangoes below. Take the shapes of the fruits or veggies and play around with design. Repeat the shape, make it larger, make it smaller, let the colors run one into the other. I did this piece with watercolor and colored pencil, but you could also use pastel. The idea is to take the structure of whatever veggie you're drawing, break it apart, and reassemble it in the way you like. Scale, color, repetition, cropping, richness of color and texture: All of these ideas can lend themselves to an abstract drawing. Have fun!

Mango memories, watercolor and colored pencil

Recipe ingredients:

1 recipe pastry for a 9" (22.9 cm) double-crust pie

½ cup (112 g) unsalted butter

3 tablespoons (24 g) all-purpose flour

¼ cup (60 ml) water, room temperature

½ cup (100 g) granulated sugar

½ cup (115 g) brown sugar, lightly packed

8 Granny Smith apples peeled, cored, and sliced

Directions:

Preheat oven to 425°F (220°C, or gas mark 7)

Melt the butter in a sauce pan. Stir in flour to form a paste. Add water and sugars. Bring to a boil. Reduce temperature and simmer.

Line a pie pan with crust. Fill with apples, mounded slightly. Cover top with a lattice work crust. Gently pour the sugar mixture over the crust. Pour slowly so it does not run off.

Bake 15 minutes in preheated oven. Reduce the temperature to 350° F (180°C or gas mark 4) and continue baking for 35 to 45 minutes or until apples are soft, and crust is lightly browned.

Recipe, Michele's apple pie

Harvest Time

"Harvest time, to me, means time for some good ole homemade apple pie! On a crisp fall day, what could be better? Here is my personal recipe and a few drawings to go with it. Hope you enjoy the results of your baking!" —Michele

EXERCISE 28

Following the recipe at left, bake an apple pie and create a watercolor illustration of the finished pie, while you enjoy a slice of your efforts. Begin by mixing some colors that feel right, to create an abstract pattern in roughly the shape of the pie. Then, using a dry brush, pick a darker color to create the line work. Then merge the two images together into one picture using your computer or color copier. Combine your illustration with a copy of this recipe and give it out to friends and family. If you truly don't like baking, buy an apple pie to draw from (and eat!) and create the same illustrated recipe sheet. No one has to know you didn't do the baking yourself, unless you choose to tell (your secret is safe with us). You can substitute your own recipe too, of course, and a little ice cream for some à la mode never hurt anyone either.

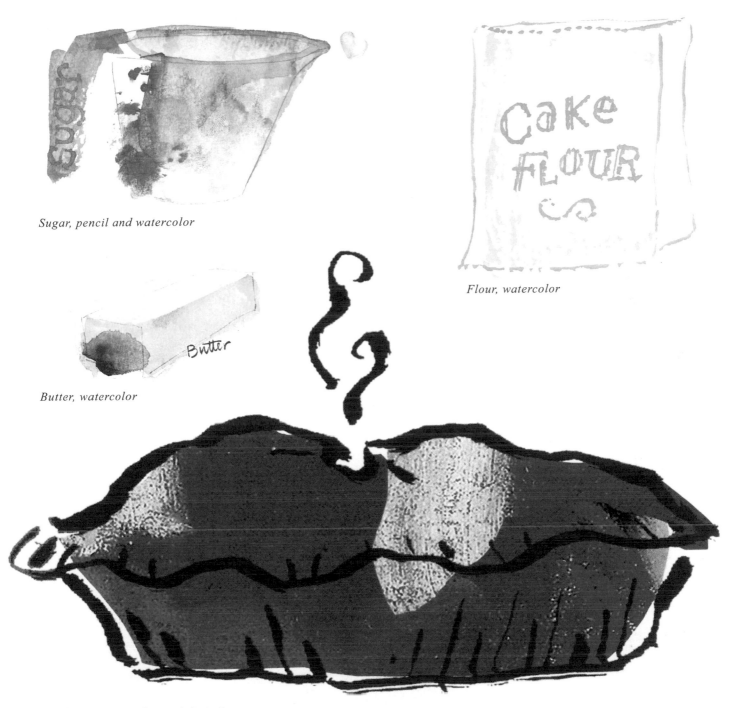

Sugar, pencil and watercolor

Flour, watercolor

Butter, watercolor

Apple pie, watercolor and digital art

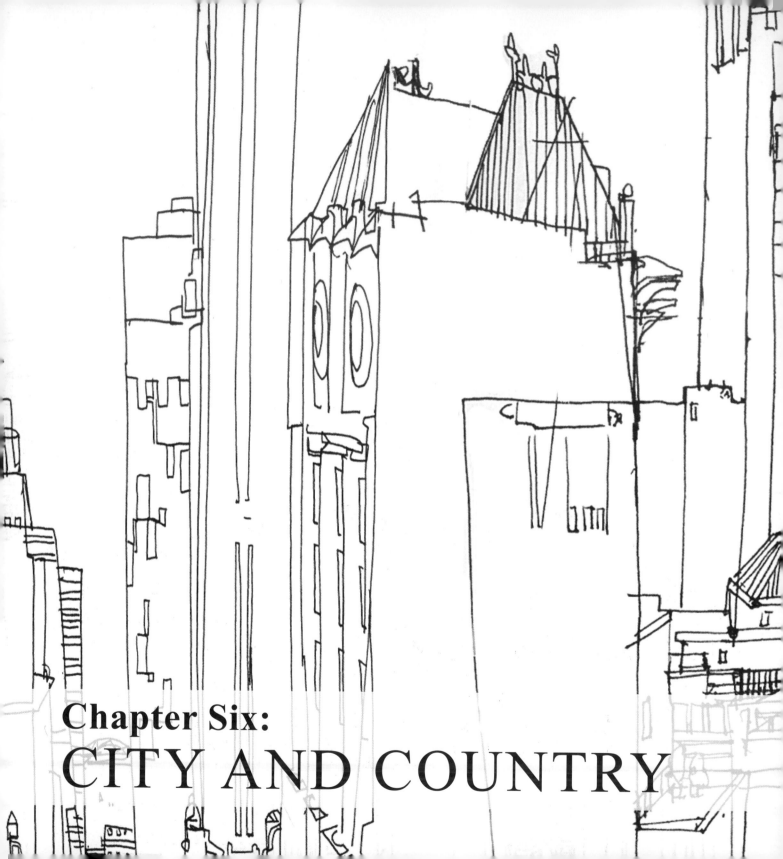

Chapter Six:
CITY AND COUNTRY

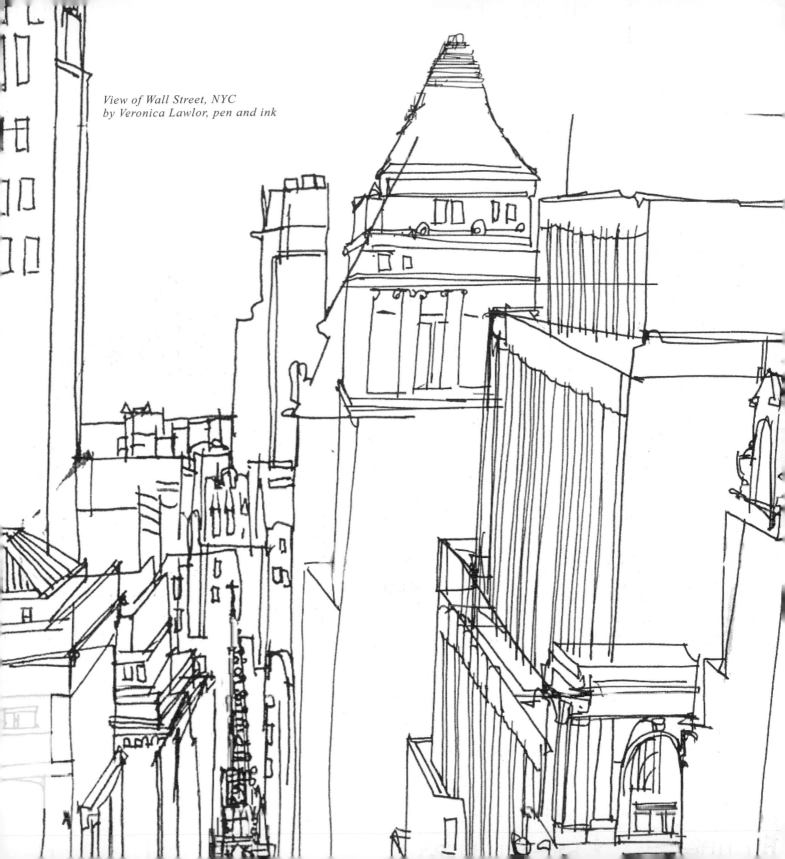

*View of Wall Street, NYC
by Veronica Lawlor, pen and ink*

The City in Seconds

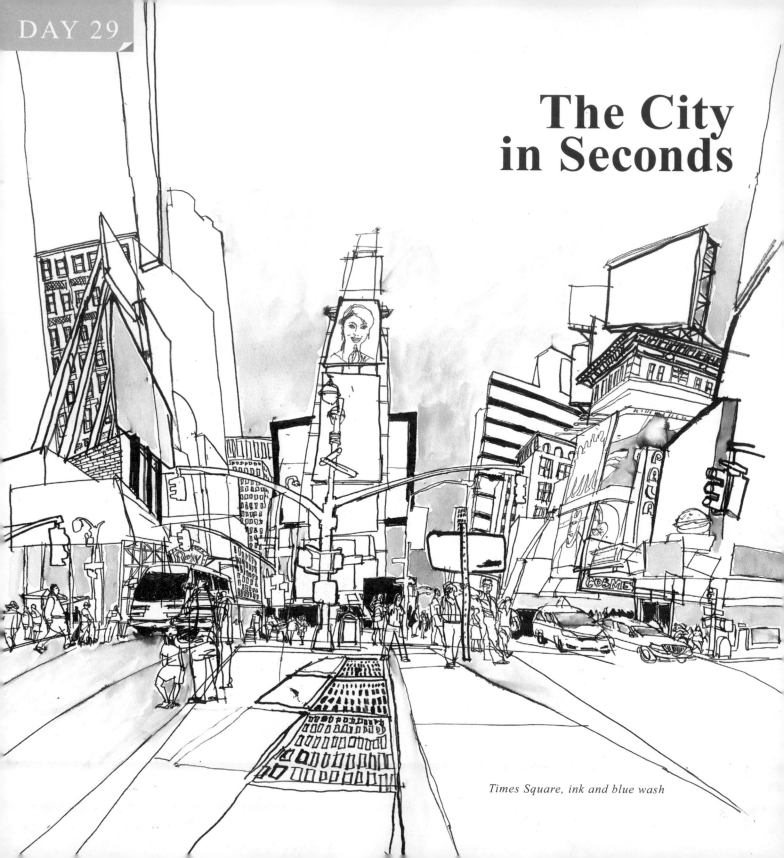

Times Square, ink and blue wash

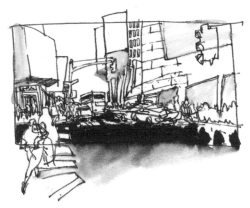

"I love my New York City. I feel so comfortable walking down my streets. I have not a worry in the world. Now, of course, I have all four eyes open: It's still New York City, after all.

"I did these small thumbnails to get a few quick views of Times Square, and then came back the next day to do the larger drawing." —Eddie

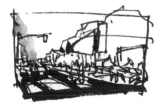

Times Square thumbnails, ink and wash

EXERCISE 29

This exercise is called "The City in Seconds" for a reason—you shouldn't take more than sixty seconds or so to do each thumbnail! A thumbnail is a small sketch of a picture that professional illustrators use to decide on picture design and content before committing to the final image. It helps as a tool to work with art directors as well. Using a portable fountain pen and a small sketchbook, go to the busiest intersection in your town. If you live in New York City, head over to Times Square, by all means! Make four small box shapes on your page and, turning to face four different directions, do a quick thumbnail of each. Choose one of these views to make a larger drawing from.

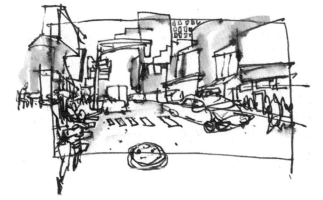

TIP

- A small portable water brush will allow you to add wash to your thumbnails (and main drawing) while still keeping your materials light. Look for one that has a screw-in refillable barrel.

Joshua Tree National Park

"Below is a drawing/watercolor I made when I took a trip out to the Joshua Tree National Park in California, one of the most beautiful places I have ever seen. What a challenge to draw ... there are huge slabs of rock scattered about and, in this particular scene, a few sparse pieces of vegetation. It is so monumental that I asked myself, 'How do I create anything more beautiful and sublime than what I'm already looking at?' Of course, I tried anyway!"
—Margaret

Joshua Tree National Park, pencil and watercolor

EXERCISE 30

Go to the most beautiful landscape you can think of. Bring your watercolor set, some water-soluble crayons, your pad, and a few pencils, and spend the day creating pictures of the beauty in front of you. Choose a nice, sunny day and bring a picnic lunch for yourself as well. Have fun with your "plein air" painting and enjoy the day, impressionist-painter style!

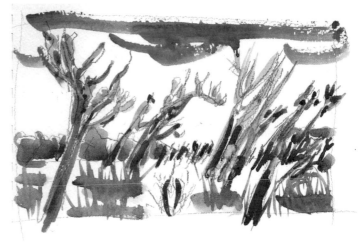

Vegetation, pencil and watercolor

VARIATION

After you've completed the main landscape view, you might want to do some additional paintings of smaller aspects of the landscape, as Margaret has done here with her watercolor paintings of the vegetation and individual Joshua tree.

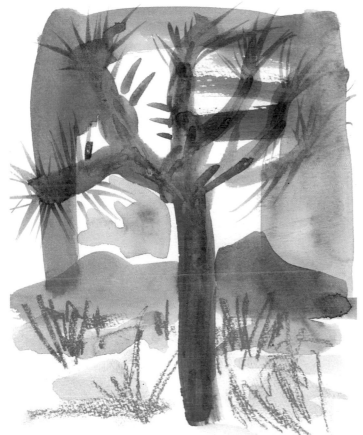

Joshua tree, watercolor and water-soluble crayon

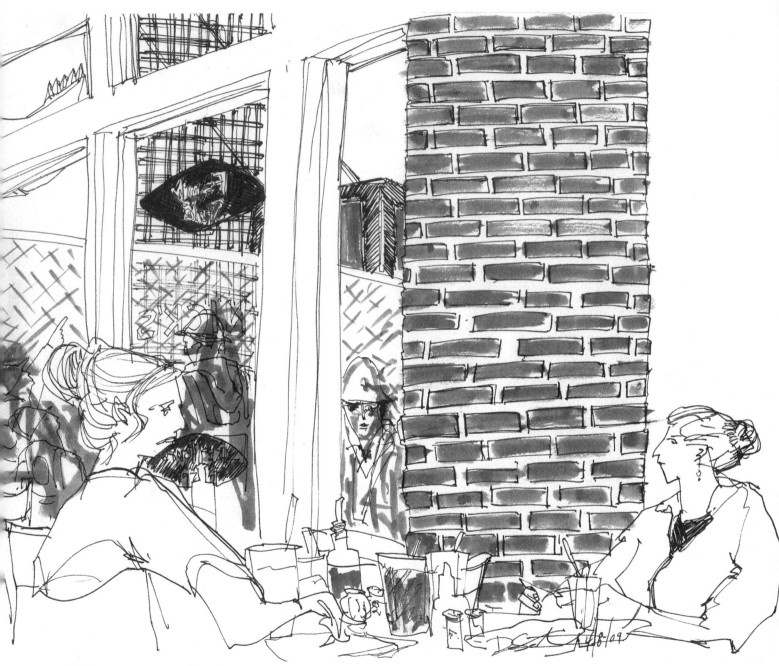

Nick's pizzeria, pen and brush

I Miss Pizza

"No offense to the local pizza shops in my new hometown, but I miss Nick's. Hands-down, it's the best pizza in New York. They don't sell it by the slice, but I never had a hard time polishing off two-thirds of a pie—and who doesn't like a slice or two for breakfast the morning after? I drew this during an afternoon visit last April—okay, that day it was hard to polish off a whole pie—when I was taking a break from drawing the construction on the street for the new subway line in New York City on Second Avenue. The women in the drawing were a little freaked out over the commotion caused by the work going on outside." —Dominick

EXERCISE 31

Go to your favorite eatery and make a drawing of it. Use a fountain pen with black ink and add some gray tones with a brush marker. Try to go during mealtime so you have plenty of patrons to draw as well—no need to create a bad advertisement of an empty place for your favorite restaurant! Position yourself at a table where you can see the action: people eating, the waiters coming and going, take-out traffic if there is any. Make a few little thumbnails before you jump into the larger drawing. Of course, get yourself something nice to eat: After all, this is your favorite restaurant for a reason. You could thumbnail while you wait for your food to come …

Bricks, detail

Window, detail

TIP

- Pay close attention to details that identify the location. In this example, Dominick has emphasized the brick walls and also the construction going on outside. Don't neglect the restaurant windows and what is happening on the street beyond. As in the case of Dom's favorite NYC pizzeria, the street scene is definitely part of the ambience!

Scenic Views

Village of Oia,
colored pencil

"I can dream of Santorini 'til Christmas if I want to—why not? I almost don't remember making this drawing [above] on the Greek island, because of how delirious I was becoming from the heat. The island is baked in a beautifully intense sunshine that never lets up!! Back at the hotel that night, I was looking through my drawing pad and thought, 'When did I do that?' This is a famous and much-photographed spot on the island, the village of Oia." —Despina

"This drawing [below, right] is from a summer when I spent the better part of my time reportage-ing around New York City. Often I feel overwhelmed at Rockefeller Center, maybe because there is so much to look at: great art, tons of people; I don't know, but on this day I was able to focus on the seasonal restaurant [it covers the ice skating rink in warmer weather] and draw from a pretty interesting point of view." —Greg

EXERCISE 32

Choose a scenic spot, either city or country, and make a drawing from that point of view. It could be the best overlook of your town, an interesting urban viewpoint, looking down, looking up—anything that is out of the usual vision would work for this exercise. If you have access to a balcony, this would be the time to take advantage of it! Use graphite pencil and colored pencils with a bit of crayon, as Despina and Greg have done here. Have fun showing off the best view in town!

TIP

- At such a distance, small details are going to be hard to see and put down. Focus on the larger shapes and identifying information that needs to be in the picture. Allow your color to be more emotional than representational.

Rockefeller Center, graphite, colored pencil, and crayon

Romantic New Orleans

"*New Orleans is such a romantic city—the jazz music, the voodoo vibe, the Mississippi River, the wrought-iron architecture, and the clomping of horse hooves on the cobblestone streets. Not to mention the warm weather and, in springtime, the smell of honeysuckle blossoms in the air. Mix that with the slow pulse of the paddleboats and the sounds of gypsy guitars in your mind— don't you feel relaxed already?*" —Veronica

Paddleboats on the Mississippi River, pen and ink

EXERCISE 33

Create a travel postcard of your favorite city or village: either one you visit or your hometown. Find the most unusual thing or things about the place and make some drawings of it: pen and ink, pencil— add some color, too, if you want. Then, break that drawing down into postcard ideas, similar to the way I've used aspects of the New Orleans paddleboats to come up with the three poster thumbnails at top right. This is called using your notes in reportage: taking small aspects of something and amplifying them—for example, the smokestack from the paddleboat becomes a poster image all by itself. This is a great way to get the most visual mileage out of a day spent on location!

New Orleans postcard thumbnails,
pen and ink, marker, colored pencil, pastel

VARIATION

In addition to creating your postcard sketches from aspects of a particular scene you've drawn, you might try simply cropping out parts of your drawing that make a nice postcard as well. Take a piece of tracing paper and lay it over your location drawing. Cut a rectangular shape out of cardboard. Lay the cardboard cutout over the work and tracing paper and trace interesting smaller pictures from the larger one.

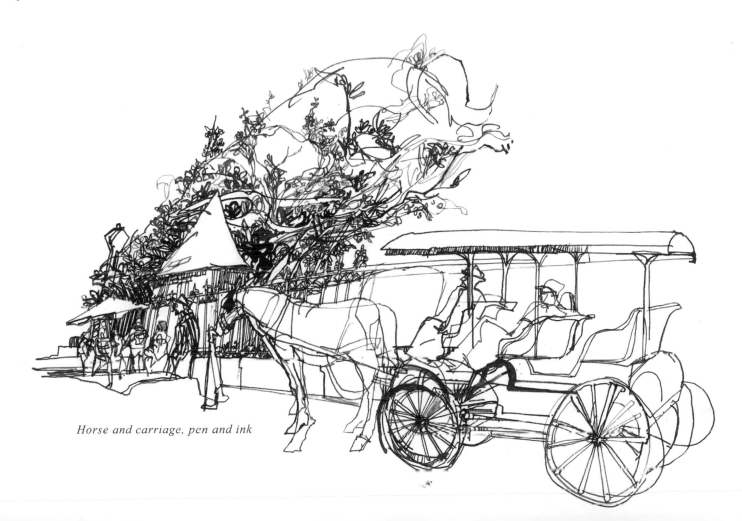

Horse and carriage, pen and ink

Uptown Bridge

"These quick, messy ink drawings are of the New York City side on-ramp to the George Washington Bridge linking New York and New Jersey. I have a whole stack of drawings toward a series I'm calling 100 Views of the GWB. *I was inspired to do this by Hokusai, the Japanese artist who famously created* 100 Views of Mount Fuji *near Tokyo. I was also inspired by the industrial elegance of the bridge, a landmark that dominates my neighborhood."* —Kati

George Washington Bridge One, pen and ink

TIPS

- Working with loose ink on location can be a challenge. You might try a clip-on ink pot; many art supply stores carry them. This frees your hands for drawing.
- Kati remembers that it was very important to draw from a nice comfy spot with a ledge to lean her pad on. Also, try carrying an old cloth with you so you are prepared to clean up the inevitable ink spills that will occur! Of course, those are the best parts of the drawing.

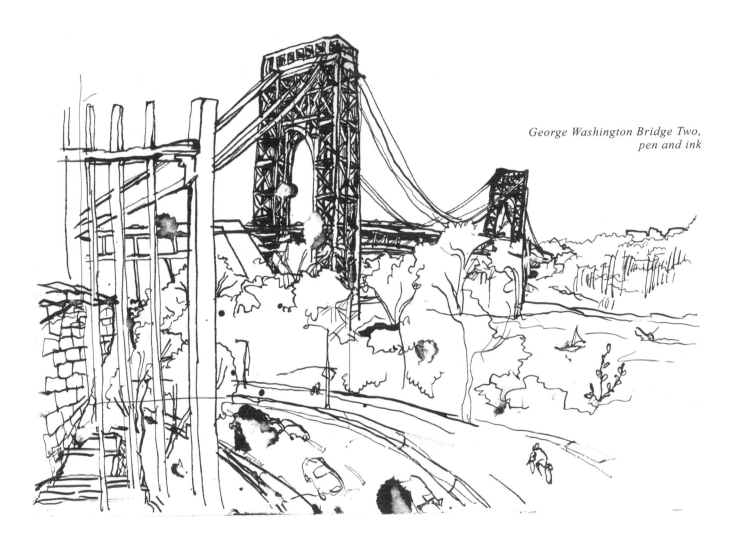

George Washington Bridge Two,
pen and ink

EXERCISE 34

Select a landmark of your neighborhood, be it urban, suburban, or country, and resolve to spend a few hours documenting it with drawings. Get a sturdy board that you can lean on to draw, such as one made of Masonite, and use some clips to attach a few pieces of paper to it. Walk slowly around the landmark that you wish to document and make some small designs of the different views you see as you are walking around. Take no more than an hour to do this. Pick three that you like, keeping in mind that variety is the spice of life. Take your time; make the drawings you selected in a very relaxed manner. You want the feeling of the place to come through, how *you* feel about it, so getting uptight about the drawings won't do at all! Use a thick quill or bamboo pen and loose ink to achieve a graphic quality, as Kati has done.

*Eiffel Tower, pencil,
pastel, and oil crayon*

Homage to Cocteau

"True realism consists in revealing the surprising things which habit keeps covered and prevents us from seeing."
—Jean Cocteau

"What a perfect description of the magical art of picture making. And Jean Cocteau's beautiful way to describe realism is even more appropriate to consider when drawing the Eiffel Tower of Paris, a monument to romantic fantasy." —Michele

EXERCISE 35

Using deep, rich colors such as pastels or oil crayons, sit at your table and make a drawing of a place you have always fantasized about visiting. Let the romance of your destination influence your color choices and marks. You might choose a landmark of the place, such as the Eiffel Tower, to help identify it for yourself. Or not—remember, this is a picture for you and you alone. Save it to bring with you when the day comes that you actually make the journey!

TIP

• Reading some poetry or quotes pertaining to your fantasy destination can help you get ideas as to what to draw and how you want the drawing to feel.

Chapter Seven:
IDEAS, HOLIDAYS, AND SPECIAL PROJECTS

Time Waiting, *by Dominick Santise, pencil and ink and wash*

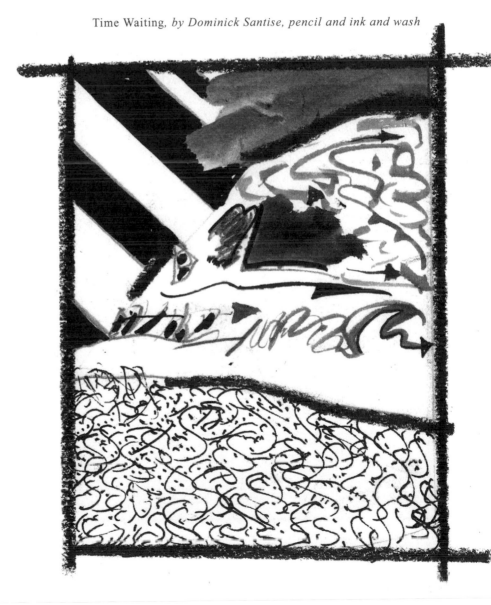

Omphalos *mood board, watercolor, charcoal, and colored pencil*

Mood Boards

*"This is from a series of mood boards designed for a personal animated
project called* Omphalos. *The word* Omphalos, *a symbol of the Earth and all
birth, means "navel" in Greek. The people of Omphalos believe the world
began with them and that they are the center of the Earth. They worship the
god Omphalos, to whom they give credit for their existence. What they don't
know is that they are living under a façade created by another people, who
use them to supply their own needs. This project is an embodiment of who I
am, speaking to the things I love: good versus evil, love triumphing over hate,
power beyond human understanding, the will to fight, honor, respect, the
spirit, faith, hope, mistakes, life, and family. I have combined cultures and
philosophies through graphics and icons that help me communicate these
ideas, and worked with them through these mood boards." —Eddie*

EXERCISE 36

A mood board is something designers use to decide what kind of feeling they
want a project to have. For this exercise, create a mood board that reflects a
place that had a great emotional impact on you. It could be a favorite vacation
destination, a place where you had a major experience, a place you visit
frequently, even a home you used to live in. Think of symbols and iconic
images that really represent the place for you. Explore the colors, pattern,
textures, and marks that reflect your feelings. Perhaps you could indicate the
dominant culture of the place, if it seems appropriate. This is really an
exercise in abstraction and finding your own personal language.

Mood board, charcoal and pastel

Orchid
Show

Sahlep species: Orchis
m.bedigian 2010

Orchid, pencil, watercolor, and digital collage

"An annual visit to the orchid show at New York Botanical Garden is such a delight for the senses. The year I drew this, the show featured Old Havana and the Cuban countryside, *designed by Jorge Sanchez. I can't plead with you more: Mark it down for next spring and make the trip. The orchid show is truly incredible and is only there for a short time each year. Happy spring!" —Michele*

Each spring, the New York Botanical Garden in the Bronx is home to the annual orchid show. Prized for their delicate beauty, orchids made up the world's most diverse plant family: There are estimated to be 30,000 to 40,000 species.

Maenad, colored pencil, watercolor, and oil crayon

EXERCISE 37

Go to a flower show or make an arrangement of flowers at home. Choosing one flower in particular as your focus, create a mixed-media illustration using watercolor, pencil, pen, and digital collage. Use old botanical prints and ephemera purchased from your local thrift shop to add some old-fashioned flair to your design. Scan your thrift store finds along with your drawing into the computer and pull pieces from the collage elements to lay over the art. You'll need a program such as Photoshop to do this. (If you don't have computer access, glue and scissors work just as well!) Add some words if you like, as Michele has done here. Go beyond a simple flower drawing to create an update on the old botanical prints of years ago. The idea is to capture the emotional sensation of the flowers' beauty and include a sense of history, too.

TIPS

- You might look up the ancient symbolism of the flower to help you choose what external elements to collage into your picture. The mythology associated with the orchid alone can lead you down a dozen paths!
- The Studio 1482 members often use research on ancient mythologies to inform their illustrations. The drawing of a maenad from Greek mythology that I did, above, is an example of that. Here's a hint: The maenads are related to the orchid's mythological story!

Earth Day

*Red cardinal, pencil,
watercolor, and collage*

"Happy Earth Day, everyone. I was doing a bit of reading on the subject and I came across the EPA's 'It's My Environment' promotion. And while I didn't make a sign and a video as they suggested, the promotion did get me thinking about my environment and what I can do to care for it. Recently I've been considering some upgrades to my backyard, and it only took Google and me a few minutes to find countless ways to enhance my yard responsibly. Using ecofriendly driveway materials, harvesting rainwater, and using compost rather than chemicals are just a few [easy and cheap] alternatives to conventional methods. At this point there is simply no excuse for you not to do your part.

"Here is a cardinal that lives in my yard (and an actual piece of the yard, too). It's one of the many reasons I'm trying to be more environmentally conscious."—Greg

Rock from Greg's garden, photograph

Stick from Greg's garden, photograph

TIP

- Choose pieces of nature that will work well with collage. If you want to represent the mountains, for example, you might choose a small pebble or two. Let the small represent the large, the same way that small things can make a large difference environmentally.

EXERCISE 38

Create your own Earth Day poster that illustrates one thing you can do to "go green." Visit the library or do an online search to find some information about how to be environmentally responsible. The drawing for your poster can illustrate anything that represents going green—turning off the lights, composting, refusing to use plastic bags at the grocery store—whatever you can do that helps the environment. The key is that it should be personal, not something that needs to be done on a large scale. Then think about nature. What do you love the most about the environment? Go out to your backyard or visit a natural place that you love—a beach, park, and so forth—and find a symbol that you can add to your drawing. It could be a leaf, a blade of grass, or a small stone. Create the drawing and collage in the small piece of nature that represents what you love, using the actual piece, a computer scan, or a photograph that you take of it. Put it together by hand with glue or assemble it in the computer. Make it beautiful, like Earth!

Day at the Museum

mosaic w/ allegorical female

kids at play =
girls = flowery nymphs
boys = knights in melted
castles + forts

(rooftop chimneys →)

Visual notations from the Spain/Gaudi exhibit at the Metropolitan Museum of Art, pencil and crayon

"Few things compare to the pleasure of going through a museum and drawing what catches your eye. I love browsing through museums and taking emotional notes with either my brain or my pen. Or, in this case, with my pencil and crayons." —Kati

EXERCISE 39

Visit a local museum with a small sketchbook and a few portable materials, such as a pencil, fountain pen, and a few crayons. Walk through the museum and make drawings of whatever strikes your fancy. Jump from gallery to gallery and don't overlook the decorative arts in favor of the paintings. There is no end result to this exercise other than a sketchbook full of visual notes that you can refer to again and again. If there is no museum near you, do this exercise at an antique or curio shop. Ask for the owner's permission to draw there first, of course.

Vase, grape harvest, pencil and crayon

Museum visitors, pencil

Earth Calendar

**August 10,
International
Biodiesel Day**
*Biodiesel was discovered
on August 10, 1893.*

"*So maybe you've noticed, most international holidays are just that: holy days. And some holidays commemorate a special political event or human achievement. I did some quick research and found some fascinating holidays that are going on almost every day of the year. I thought it would be a great project to come up with an illustration for the holiday each day. Since I often didn't know what the holiday would be until the day it arrived, I was challenged to use my knowledge of drawing and graphics to solve it on the spot. I used mixed mediums, looked up the daily holiday online, and let my imagination run wild.*" —Despina

Cornflower as energy, crayon drawing

Lotus temple in India, marker and colored pencil

July 9, Bahá'í faith holiday *The mission of the Bahá'í is to spiritually unify all the people and all religions of the world. It may be painfully idealistic, but that's something I truly believe in myself! If only the Bahá'í's message of peace, justice, and unity would be heard!*

EXERCISE 40

Walk over to your computer (or visit one in a library) and do some research to find a holiday that is being celebrated somewhere in the world today. It can be anything that creates an interesting visual in your mind, not just the holiday that seems as if it is the most important. Create a drawing that illustrates the holiday in some respect. Use any medium you choose or mix them for even greater graphic expression. Take no more than two hours to complete the drawing.

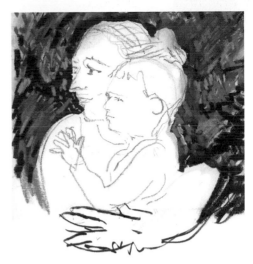

Fourth of July generations, marker, pastel, colored pencil

Fourth of July, generations past and future *Grandma and grandson are watching the fireworks display together. We should all take this day to remember where the U.S.A. started and imagine the possibilities of where it could go. It's not only about hot dogs and potato salad!*

TIPS

- Let the culture that the holiday comes from affect the kind of drawing you do. It could be a color that is used a lot in the art of that country, a design style, or a symbol that you see that country employ. Or you might think about a visual explanation of the politics or information that the holiday celebrates. Can you understand what it is without words?
- That being said, don't feel that you can't add your own ideas to the illustration; after all, you are interpreting the holiday through your own artistic sense.

A Partridge in a Pear Tree

"On the twelfth day of Christmas, my true love gave to me ... twelve charming elephants, eleven turtles makin' groovy, ten skaters skating, nine mocko jumbies dancing, eight limbo dancers, seven swans a-swimming, six saguaro cacti, five peace roses, four angel drawings, three happy dancing doves, two Japanese dancers, and a partridge in a pear tree!

"When I was a kid, Christmas took forever to get here. I grew up in St. Thomas, U.S. Virgin Islands, and my relatives sent packages down to us from the States. They were put under the Christmas tree and became ginormous—they emitted heat waves! By the time Christmas morning came I fell on top of the packages like a ravenous wolf ... I had waited so long for that moment! I miss those days of eternal yuletide yearning." —Margaret

EXERCISE 41

Illustrate your own holiday card. You could draw something traditional, as Margaret did with the image of the partridge in a pear tree, or do something all your own, as she did with the illustrations for the rest of that Christmas carol!

TIP

- Create a limited edition of the cards by printing them out from your digital printer and numbering them as they come out. Have fun with the symbols, colors, and images of the holiday season!

Partridge in a pear tree, pen and ink

Five peace roses, pencil, crayon, and watercolor

...on the third day of Christmas my true love gave to me, Three Happy Dancing Doves...

...and a partridge in a pear tree

*Three happy dancing doves,
pen and ink with digital collage*

Haitian Relief

In response to the earthquake in Haiti in February 2010, the illustrators of Studio 1482 each donated art and limited-edition prints to be sold to raise money for the victims, with the proceeds going to the appeal for funds from CARE, a leading humanitarian relief organization.

EXERCISE 42

Choose a worthy fund that you would like to support and create a piece of art that shows some aspect of what the organization is about. Create a limited edition of prints with your home printer or by taking the art to a local print shop. Sell the prints and donate the proceeds to your charity of choice. An online store, like Etsy.com, makes it easy to set up shop!

Help Is a Verb, Michele, pencil and watercolor

Life, Eddie, ink, watercolor, and crayon

1791, Kati, ink

Aid for Haiti, Despina, pen and ink, colored pencil

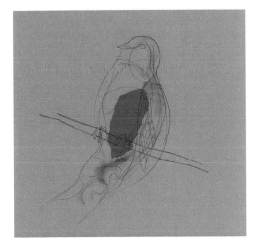

Hispaniolan Trojan, Greg, pencil and paint

A Rose for Haiti, Margaret, pencil, watercolor, and crayon

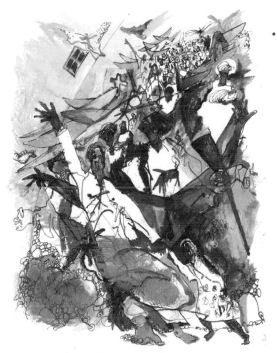

Waiting for Help, Dominick, pen and ink, watercolor, crayon

TIP

- When pricing your prints to sell, there are a few things to consider. Price higher for larger prints on better paper and lower for small prints on more inexpensive stock. An original piece of art should always be priced higher than any prints.

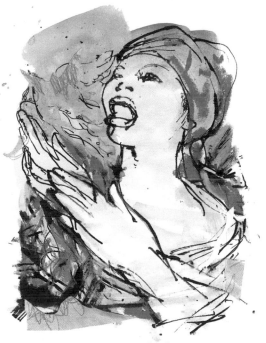

Spirit, Veronica, pen and ink, watercolor, crayon, and cut paper

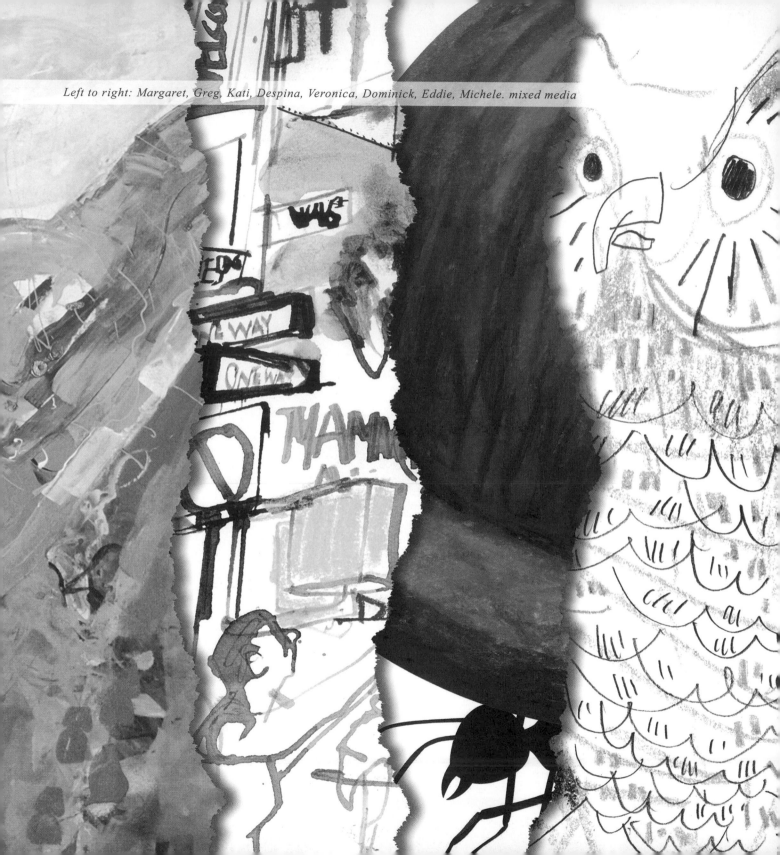

Chapter Eight:
GALLERY

Michele Bedigian

Take unusual color combinations and interesting graphic textures, add a little knowledge and feeling for culture along with an elegant sense of design, and you get the whole picture of Michele Bedigian's work. She is a visual artist through and through, and her work ranges from textiles to advertising, publishing to package design. Michele's communication solutions have been demanded by many top agencies, including Godiva Chocolatier, DDB Advertising, and DiNoto Advertising, as well as several publishing houses. Michele is a graduate of Parsons School of Design and the Passalacqua School of Illustration. Her watercolors have been exhibited at the Metropolitan Museum of Art and the WomanMade gallery, among other venues. Michele's work is sought after by numerous private collectors.

Years back in the midst of study I realized that, for me, the goal in my art has always been to find synergy between the way I think and the way I express thought.

I guess in all creative disciplines that stem from passion, the effort can be a risky venture. I've learned that the solution actually resides in the risk, and even more so in the mistakes. It is only there that honest growth can be revealed.

PACKAGE DESIGN inspired by the Aztec civilization and their incredible relationship with the cocoa bean. Created as a marketing solution in consultation to Godiva Chocolatier.

STUDY, BIRTHDAY WISHES.
Artwork commissioned to honor the
birthday of Karen Berg, cofounder of the
Kabbalah Center in New York City. It was a
privilege to be such a part of a divine
proportion in the making.

PAINTING, ANCESTORS,
Saigon Collection, 2009.
Part of a series, this piece
was inspired by a commercial
assignment I was hired to do
for FSG publishing: a book titled
Escape from Saigon, by Andrea
Warren. The art is a visual
impression of the last memory
of a child's grandmother before
his life was destined to change.

Greg Betza

Greg Betza is an illustrator, artist, and designer from New Jersey. His versatility in style and unique approach to problem solving has led him to create work for a diverse group of clients across many industries. Greg is a graduate of Parsons School of Design and has also studied extensively with the late David J. Passalacqua.

Greg has received numerous awards from institutions such as the Society of Illustrators of Los Angeles, *Communication Arts,* and *American Illustration.* In 2010, Greg was featured in *Communication Arts Fresh Online* as one of the industry's top emerging illustrators.

I believe in the importance of an individual's unique point of view. Art is how my voice is heard as well as my contribution to our culture. I feel a responsibility to be a translator of the times that I'm living in, as I've always appreciated the contributions of the artists of the past. I find the drawings and paintings created by the people of the past to be far more telling than any history book.

BAY OF AMMOUDI, 2009.
A colored pencil drawing made at the Bay of Ammoudi in Santorini, Greece. This drawing is from a series of more than fifty drawings made during my trip to Greece in 2009.

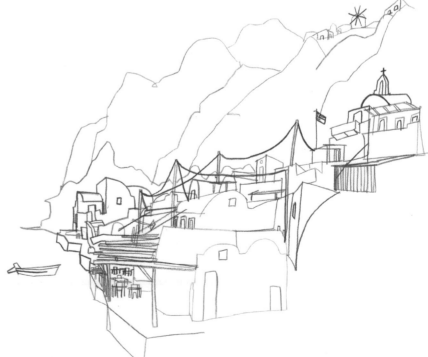

CAROUSEL, 2009.

Pen and ink drawing is one in a series made at Van Saun County Park in Paramus, New Jersey. I spent the day with my family enjoying the park and practicing my drawing. Nearly a year later, this drawing was seen on my blog by Australian fashion designer Collette Dinnigan, who made it a finalist to be used as the art for her Paris show invitation.

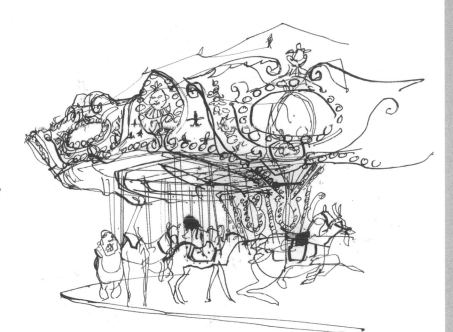

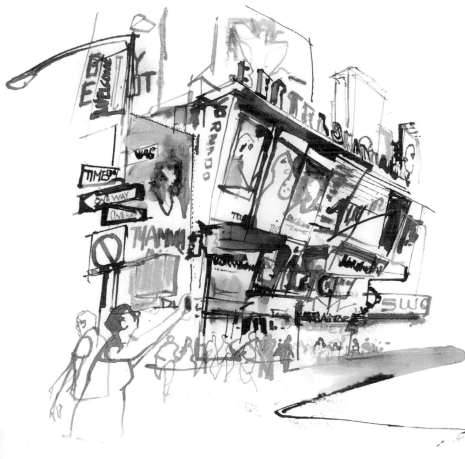

TRAFFIC-FREE TIMES SQUARE, 2009. Pen and ink and crayon drawing created on a Saturday afternoon in June 2009, shortly after NYC put a ban on cars in Times Square. The series of drawings made that day were accepted into the 2010 *Communication Arts* Illustration Annual.

Despina Georgiadis

Despina Georgiadis and her son, James

As an illustrator, designer, and children's book creator, Despina Georgiadis loves to experiment with drawing materials and different ways of working. By keeping drawing as the foundation of her image making, she is able to discover new visual ways to tell a story.

A graduate of Parsons School of Design, Despina works from her home studio in New Jersey, which she shares with her three-year-old son, James.

I like to find the magic that lives all around me and express it through my art. Really, that's basically it! For me, the simple act of drawing holds the potential to dazzle. For instance, when I draw with my color materials, it's about the magic that light creates, making the colors sing. When I am busy working with a children's book, I'm conjuring up a story and bringing those ideas to life through drawing. Sometimes the most enchanting moments happen when I simply sit in a café, drawing the faces of the passersby.

I'm in it for these moments. I like the dazzle. I like the storytelling. And I love the drawing. For me it's just, well, magical.

STORYTELLING IS A BIG PART of Despina's illustration path. This drawing of an owl was a study in marks and textures that eventually became the subject of a children's story. Pencil and crayon

ONE DRAWING A DAY, for
Despina, means picking up her tools once
a day for as much—or as little—time that is
available and practicing her craft. Many
times it is a study in color, as this drawing
of a leaf shows. Pencil and pastel

A SPREAD FROM THE
CHILDREN'S BOOK, *My Song Is
My Friend*. For this story, Despina used a
lot of line and color to speak the language
of song, internal strength, and valiance.
She found drawing an abstract subject like
music to be challenging and fun.
Watercolor, pastel, pencil, and marker

my song is my friend

i sing to him,

and he sings to me

Margaret Hurst

I believe in energy. It fills us; it fills the universe. I appreciate the energy that exists in all things. It is my joy and pleasure as a visual artist to find and identify the individual energy that every being, place, and thing possesses and to manifest that particular energy into a visual form or entity.

These paintings are my interpretation of the roller skaters at the Central Park Dance Skaters Association that I have been observing, drawing, and painting for several years. Each skater has their own individual energy: I draw and paint this energy as motion and movements made by the skaters through line, mark, shape, and spatial identity.

Margaret Hurst is a professor at Pratt Art Institute and Parsons the New School for Design and has conducted an illustration workshop at the University of Alaska. She and Veronica Lawlor are the founders of the Dalvero Academy. Margaret is a member and vice president of the Studio 1482 illustration collective. She is the author/illustrator of the award-winning book *Grannie and the Jumbie* (Laura Geringer Books) and is also a cofounder of live2lime, a Caribbean-themed fashion line.

Margaret's clients include AT&T; Neurex; Anthology/Preface; Roche; DuPont; Knorr; E & J Gallo; MasterCard; St. Martin's Press; Stewart, Tabori and Chang; and Thomas Nelson Publishing. She has exhibited at the Society of Illustrators, the Rx Club, Messiah College, Montserrat College of Art, Tres Gallery, the Puck Gallery, and the Schaffler Gallery. Her artwork has been featured in *New York Living* and *Latitudes* magazines and is cited in the book *Early Childhood Education Today*, by George S. Morrison.

A native of St. Thomas, U.S. Virgin Islands, Margaret is a graduate of Boston University and Parsons School of Design and has studied with the late David J. Passalacqua.

ONE MOTION. This is the drawn/ painted movement of one skater over a 5-second time span. acrylic on canvas

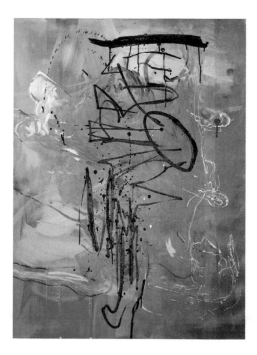

FORWARD MOTION PROPULSION. This is the moment when the skater makes the forward thrust to move. acrylic on canvas

MOTION CONNECTION. Two different skaters with different energies come together. acrylic on canvas

Kati Nawrocki

Kati is a New York–based artist and storyteller. She came to the United States from her native Germany to study fine arts at Pratt Institute and has been working in New York City as an illustrator and creative consultant ever since. Kati is the originator and creative force behind EP!PHANY cards, writes and illustrates children's books, is the voice and vision of her music blog, musikati.blogspot.com, and is currently working on a fine arts project about Wonder Woman and women's rights. In addition to these pursuits, Kati currently runs the creative team at The Economist Group in New York City and is a proud member of Studio 1482.

About EP!PHANY: What originally started as an art and research project on Japanese Buddhism has grown into a small business. The drawing at left is one of the original sketches I did at the Museum of Natural History in New York City in an attempt to wrap my brain around what Zen Buddhism felt like to me. I drew things upside down and juxtaposed items randomly to try to tap into a logic that seemed to lie beyond mere intellectual thought. Although I came up with the general idea for the cards at the museum that day, it took me another four years of research, drawing, and writing to articulate the full concept, create the final artwork, field-test the product, and put together a business plan to actually create EP!PHANY.

It is amazing where a day at the museum can lead you.

INITIAL DRAWING at the museum that eventually led to the creation of EP!PHANY. Pencil and crayon

A DRAWING from the final EP!PHANY deck depicting an ant carrying an enormous acorn. Crayon, pencil, ink, Photoshop

INSIDE MOST of us, there are strong creative and intuitive impulses, but often we consciously or unconsciously stymie them. We cling to rigid truths, and reject that which challenges us.

ep!phany cards use a carefully selected set of symbols to overcome these blocks. They embrace the idea that meaning is fluid and subjective. ep!phany cards are designed to grow with you, and help you reach your full potential.

engage! explore! enjoy! and visit us online at theanswersareinside.com

ep!phany™ cards

ep!phany

CLOUD MAN IN FRONT OF BRICK WALL: Cover of EP!PHANY card deck. Visit www.theanswersareinside.com for more information about EP!PHANY cards.

Eddie Peña

As an early lover of comic books, Eddie takes sequential storytelling to a sophisticated level with knowledge of schools, culture, and the great masters of drawing.

Comics like the Hulk were my favorite and instilled a love of art in me as a young man. I now find myself looking more to artists like Dürer and Brangwyn for inspiration when I go on location to draw and when I create storyboards for film, television, and animation.

Eddie has taken on sharing his knowledge of art with students. He is involved with programs such as F.R.E.E.D.O.M. (Free Rising with Education to Economic Development Opportunities and Mentorship), a program designed for out-of-school youth ranging from ages seventeen to twenty-one. He also works with the New York City Parks Foundation, the only

THE MORGAN, location drawing.
Pencil, watercolor, and ink

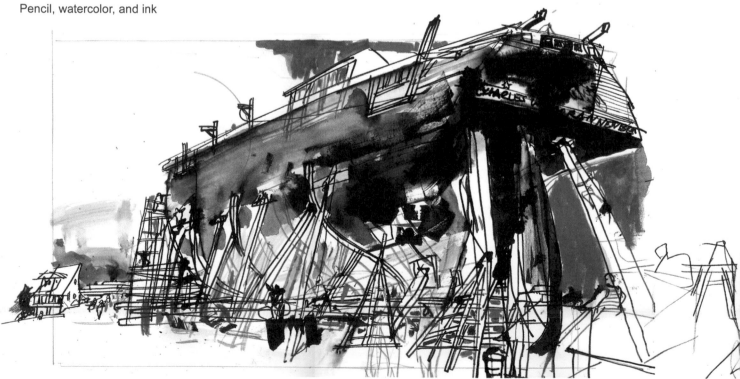

independent nonprofit that offers park programs throughout the five boroughs of New York for young people. Eddie finds joy in nurturing the young artist in each person.

"There is no delight in owning anything unshared."
—Seneca

Drawing. I love to draw and use my drawing to explore my curiosities of life. I love to study people, cultures, philosophy, science, animals, plants, architecture, and my favorite theme that I believe encapsulates life: good vs. evil.

I believe that there is more than one way to visually explain or communicate your ideas to others.

Each subject I approach stimulates new feelings, thoughts, and emotions; therefore, the marks, graphics, or design that I apply reflect that change. I will continue to explore and experiment, to discover the world through my hand and share it with others.

THE SECRET GARDEN:
PEACE. Watercolor, pencil, and water-soluble crayon

Dominick Santise

An artist who combines the poetic and the prosaic, illustrator Dominick Santise is also an experienced production man, a classically elegant designer, and an expressive draughtsman, animator, and photographer. Of late, Dominick has turned his personal time and attention to the subjects of agriculture and the environment, starting the artisanal ceramic plate project Terra Messor and contributing to the blog theenvironmentalobstacle.org. He is the author/illustrator of several stories, including *Beneath the Tree*, and has been working on images for the book *Spring Tea Party*, written by his late grandmother. After a decade in Manhattan, he returned to the Mid-Hudson Valley, where he now lives with his wife and daughters, and serves on the board of a local farm project.

I draw because I always have. I draw because I know nothing else. It is my voice. It is my solace. It is the truest me of me that there is. When there is nothing else, there is drawing. When I am lost, there is drawing. When I am found, I am found drawing. Of tomorrow I can be certain of nothing, except that I will find a new drawing at the end of my hand.

THE ART OF DOMINICK.
Promotional piece. Pen and ink

THEARTOFDOMINICK.COM
LIMITED EDITION ENGRAVING BY KARR GRAPHICS NYC ©2008 DOMINICK SANTISE

UNTIED WE STAND. Created for
theenvironmentalobstacle.org in response
to the early chaos surrounding the Gulf oil
spill. Ink and paint

SPREAD FROM BENEATH THE
TREE. Based on weeks of location
drawing in Central Park, the final book was
done in one night on a roll of narrow
cashiers' paper, as a thumbnail of what was
to come. With the advice of two dear friends,
I realized that the thumbnail was actually
the final. Ink and wash with thumbprints

Veronica Lawlor

Veronica Lawlor is an illustrator who has completed reportage campaigns for a diverse group of clients, including Brooks Brothers, the Hyatt Corporation, and the 3M Corporation. Her picture book, *I Was Dreaming to Come to America: Memories of the Ellis Island Oral History Project* (Viking Press) has remained in print for over 10 years. Her on-site reportage drawings of the 9/11 attacks on New York City are part of the permanent display of the Newseum of journalism in Washington, D.C. They are also published as *September 11, 2001: Words and Pictures*. Other exhibits and honors include the Society of Illustrators, the United Nations, Montserrat College of Art, The NYC Fire Museum, and the Ellis Island Museum of Immigration. Veronica's illustration work has appeared in numerous publications.

Veronica is on the faculty of Pratt Institute and Parsons the New School for Design and is a cofounder of the Dalvero Academy. A graduate of Parsons School of Design and the New School, she is the president of Studio 1482 and a correspondent for the Urban Sketchers international blog.

As an illustrator and reportage artist, I truly feel lucky to have had the chance to travel to so many places and meet so many people. As an educator, my sincerest hope is to pass on to my students the passion for work that I feel myself; although for them it will most surely manifest in other forms.

To draw, to connect, and to experience life through the end of my pen is really what it's all about. And it's pure bliss!

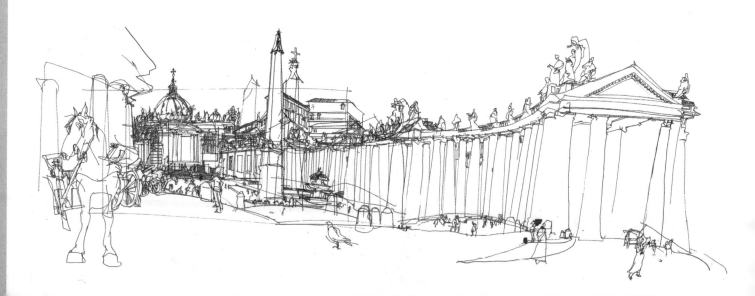

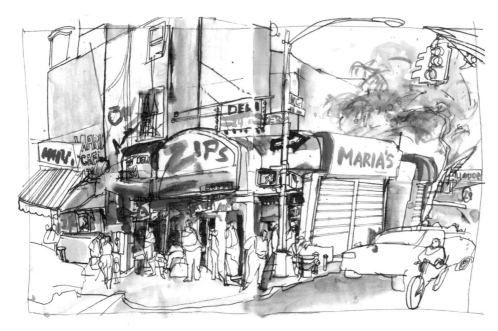

EAST VILLAGE, NYC, drawing inspired by the Ashcan school of a favorite city corner. Ink and watercolor

CARNIVAL, part of a personal project about agriculture and myth. Exhibited at the United Nations World Food Summit. Mixed media

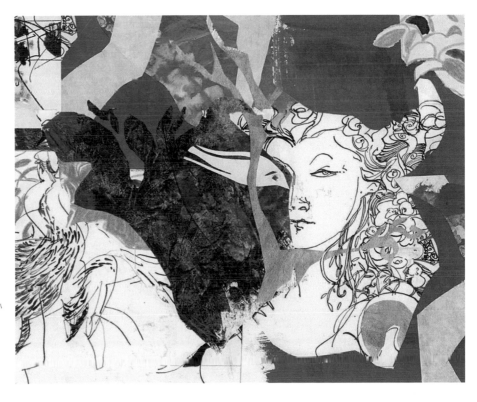

ST. PETER'S SQUARE, panoramic drawing: part of a reportage series of Vatican City in Rome. This personal project has led to several commissions. Pen and ink (left)

Acknowledgments

I would like to thank the members of Studio 1482 for entrusting me with their art for this project. Margaret, Michele, Eddie, Kati, Despina, Greg, and Dominick: I'm so glad you're each a part of my studio family. I would also like to acknowledge the late David J. Passalacqua, who taught all of us in the studio, instilling in us a lifelong love of drawing. Many thanks also go out to Mary Ann Hall, our editor, who saw the potential in the *One Drawing a Day* blog and was consistently supportive and enthusiastic about the project. To my past and present students, I want to say thank you for teaching me so much. Finally, I would like to thank my husband, Neil Weisenfeld, for his constant love and support.

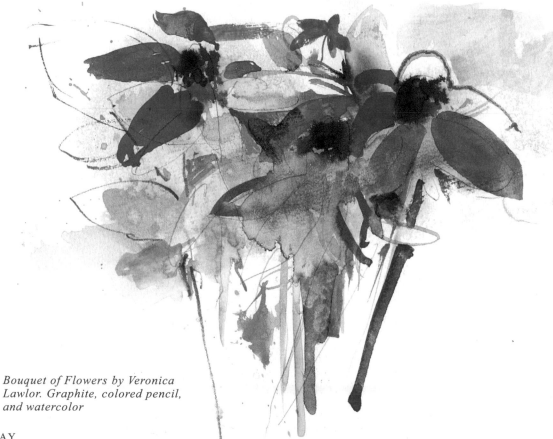

Bouquet of Flowers by Veronica Lawlor. Graphite, colored pencil, and watercolor